Published by Enemy Books/Akashic Books
©2025 Mistachuck

ISBN: 978-1-63614-204-3
Library of Congress Control Number: 2024940601

Printed in China

The Enemy Books archive is coordinated by Giana Garel, TheAgeAgency.com, GG@TheAgeAgency.com

Enemy Books is an imprint of Akashic Books
Instagram: mrchuckd_pe
X: MrChuckD
rapcentralstation.net/enemy-books
Bring the Noise App: www.rstvapp.com
btndevelopmentllc@gmail.com

Akashic Books
Brooklyn, New York
Instagram, X, Facebook: AkashicBooks
info@akashicbooks.com
www.akashicbooks.com

ONE OF MY
HEROES IS
JAC HOLZMAN
THE FOUNDER
OF ELEKTRA
RECORDS. I
CALL HIM THE
CAPTAIN AND
HIS ONGOING
STORY IS
REMARKABLE
HIS BOOK
FOLLOW THE
MUSIC IS THE
INSPIRATION

HERE HE IS WRITING NOTE
SIGNING MY ELEKTRA BOXSET HE
GIFTED ME... IN MY OFFICE...
IN MY HOME, IN MY CHAIR...

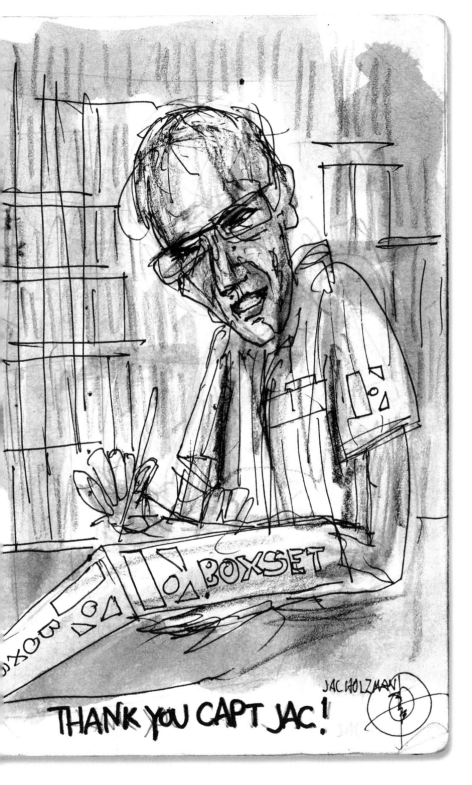

THANK YOU CAPT JAC!

I BEEN INVITED TO MR
QUINCY JONES HOME 3
TIMES TO JUST TALK
BUT MAINLY LISTEN, THE
FIRST 2 TIMES HE POINTED
TO A LOT ACROSS THE STREET
SAYING HE WAS BUILDING A HOME
OF HIS DREAMS. I WAS LIKE
HOW YOU GONNA TOP THIS?
THE THIRD TIME IT WAS
THERE, ON THE EDGE OF
OUR ROCK HALL OF FAME
INDUCTION OVER A BOWL OF
CHIPS AND GUACAMOLE, I
THOUGHT I WAS ON A
SPACESHIP LOL...

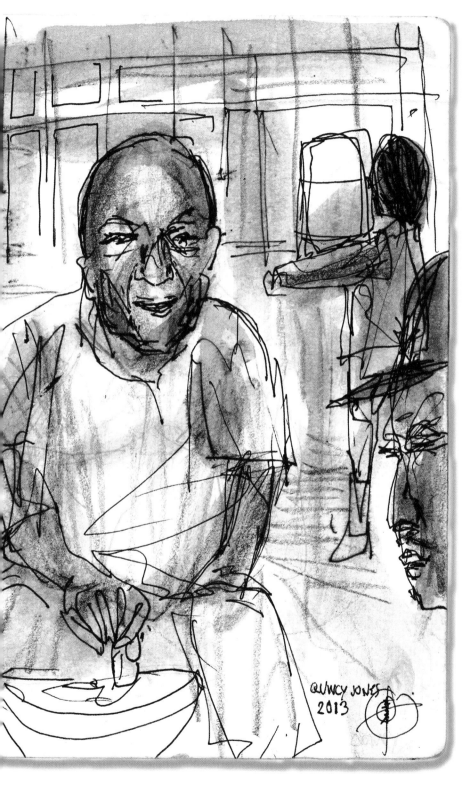

QUINCY JONES
2013

SIR BROTHER HARRY BELAFONTE
INDUCTED PUBLIC ENEMY INTO T
ROCK AND ROLL HALL OF FAME
2013. IT WAS A FIGH
TO GET IT DON

BECAUSE
WANTED
YOUNGE
TO
INDUCT
US
ON TV

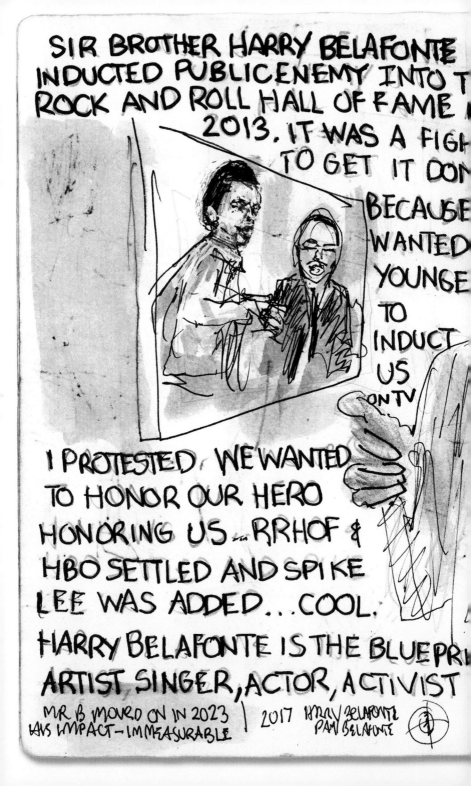

I PROTESTED. WE WANTED
TO HONOR OUR HERO
HONORING US... RRHOF &
HBO SETTLED AND SPIKE
LEE WAS ADDED... COOL.

HARRY BELAFONTE IS THE BLUEPRI
ARTIST SINGER, ACTOR, ACTIVIST

MR B MOVED ON IN 2023 2017 HARRY BELAFONTE
HIS IMPACT — IMMEASURABLE PAM BELAFONTE

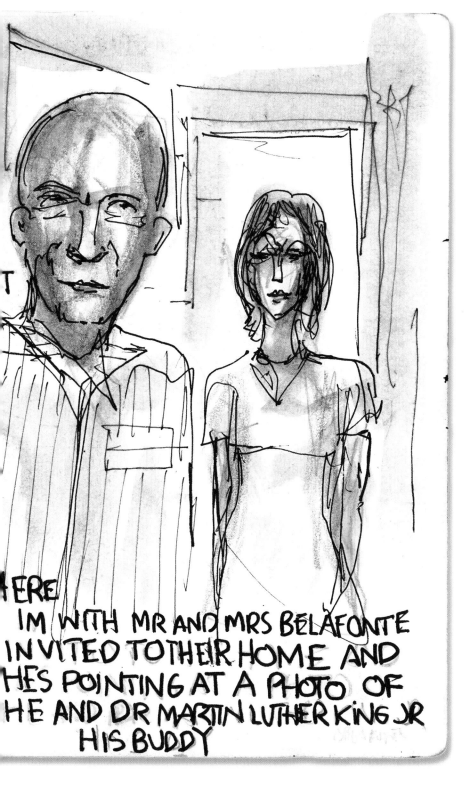

ERE
IM WITH MR AND MRS BELAFONTE
INVITED TO THEIR HOME AND
HES POINTING AT A PHOTO OF
HE AND DR MARTIN LUTHER KING JR
HIS BUDDY

AS OF THIS WRITING
I NEVER MET PRESIDENT BARACK
BUT I HAD MET A COUPLE OF
BOTH COURTESY OF THE NATION
ISLAM AND THEIR VAST CONNE
ACROSS THE AFRICAN DIASPO

ONE SUCH HEAD OF STATE WA

PRESIDENT ROSIE DOUGLAS OF T
CARIBBEAN ISLAND NATION OF
DOMINICA. MOST PEOPLE
CONFUSE IT WITH THE
DOMINICAN REPUBLIC. IT
IS NOT. WE HELPED
RAISE FUNDS FOR
HURRICANE RELIEF
THE ISLAND HAS DEEP
WATER RESOURCES. PRESIDENT DC
WAS A RADICAL FOR CHANGE IN C
AND WAS CONSIDERED A THREAT

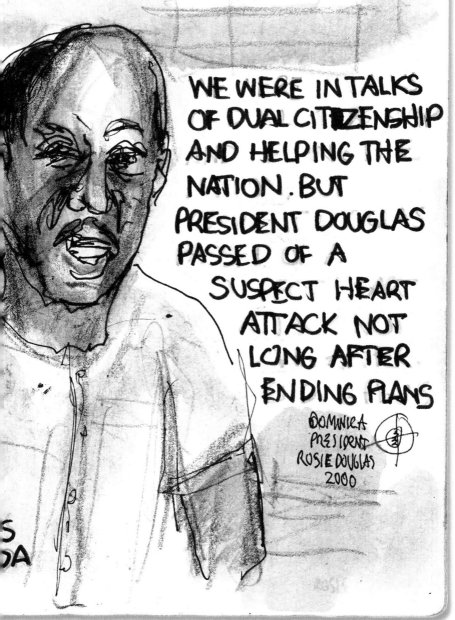

BEFORE THAT THE FIRST BLAC
JERRY RAWLINGS OF THE AFRIC
THERE AS PART OF THE PANAFE
AGAIN AS GUESTS OF THE NATION OI
WE HAD A MEETING IN ACCRA, THEI
ENDING THE MEETING PRESIDENT
RAWLINGS SALUTED US AND...

ESIDENT I MET WAS LT. COLONEL
OUNTRY OF GHANA. PE WERE
ELEBRATIONS DECEMBER OF 1992
...STARTED UP AND HOPPED
IN HIS
FIGHTER
JET

AND
DISAPPEARED
INTO THE
WEST/
AFRICAN
SKY...
THAT
WAS SO
HUGE
TO
ME!

GHANA
PRESIDENT
COLONEL LT 1992
JERRY RAWLINGS

TIMES SQUARE NYC
FINISHING A
TOWN HALL
EVENT I HEAR
A VOICE SAY
HEY CHUCK D
I LOOK AND
ITS PRINCE AND
ACTRESS LYNN
WHITFIELD IN
THE BACK I GET
IN...WELL I WAS
LIKE WOW LYNN
WHITFIELD IM AT
A LOSS OF WORDS
SHE SAYS ` WELL
KEEP IT IN YOUR
MIND' I SAID A
COUPLE OF WORDS
TO PRINCE AND WAS
OUT INTO THE STREETS
42ND STREET AREA

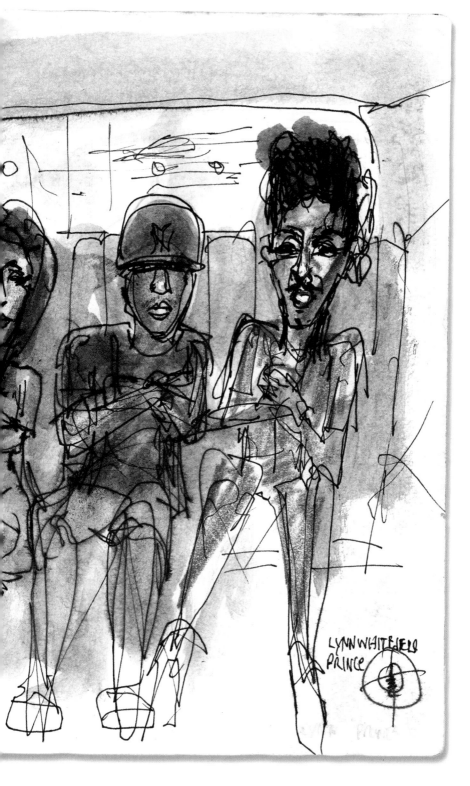

LYNN WHITFIELD
PRINCE

MRS BETTY SHABAZ
WAS SUCH A
PIONEERING
GREAT, I RECALL
DOING A LECTURE
WITH HER
BACKSTAGE I MET
HER AND REALLY
DIDNT WANT TO
TONE UP HIGH
MIGHTY WITH
RHETORIC INTO THE
CROWD SINCE SH
HAD HEARD AND
SEEN IT ALL BEFOR
SHE WAS A LEADING
PROFESSOR AT MEDG
EVERS COLLEGE IN N
FOR MANY YEARS

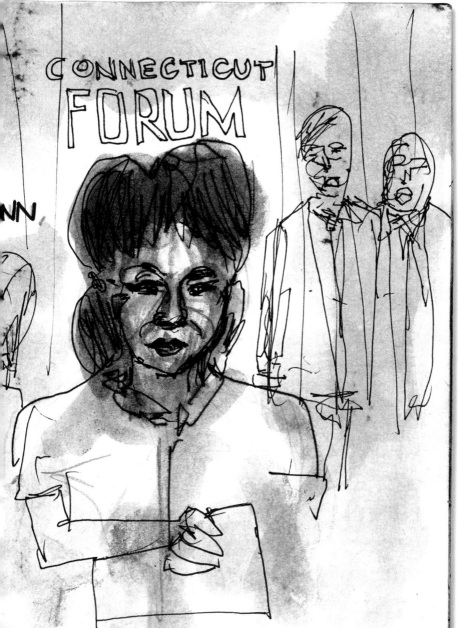

CONNECTICUT
FORUM

NN

ALSO WILLIAM F BUCKLEY
R WAS A PART OF THAT CONN
ORUM DISCUSSION ON RACE
HAD TO SHUT HIM DOWN...

1993

BETTY SHABAZZ
WILLIAM F BUCKLEY JR

I SWEAR NOBODY IN MY GENRE CRAFT KNOWS AND LUVS MOTOWN MORE THAN I DO. THEY BEEN AROUND EVERY YEAR IN MY LIFE PLUS ONE. NELSON GEORGES 1986 'WHERE DID OUR LOVE GO? BOOK WAS A READ TO WHAT I HEARD ALL MY LIFE. IN 2012 ON MY FLIGHT BACK FROM RRHOF INDUCTING THE BEASTIE BOYS. I SAT BEHIND BERRY GORDY AND SMOKEY ROBINSON. I WAS QUIET, WHERE DO I START?? BOTH TOOK A PICTURE WITH ME AFTER WE LANDED... FOREVER.. WOW!!!

2012
BERRY GORDY
SMOKEY
ROBINSON
SHERRY KONDOR

AT ADELPHI UNIVERSITY IT IS UN
THE SIGNIFIGANCE OF OUR BLACK
MUSIC PROFESSOR DR ANDRE S
OUTTA BROOKLYN HE BROUGHT A
DETAIL OF CONNECTION OF THE R
MIGHTY MEANINGS OF BLACK MUSIC,
AND HISTORY, THAT CLASSROOM H
STEPHNEY FIRST DEF JAM EXEC FOUNDE
ANDRE DR DRÉ BROWN OF TV RAD
MUSIC, HARRY
ALLEN THE
MEDIA ASSASSIN
FIRST HIP HOP
JOURNALIST

OTHERS AND I
DR STROBERT
IS OUR
COMMON
FOUNDATION

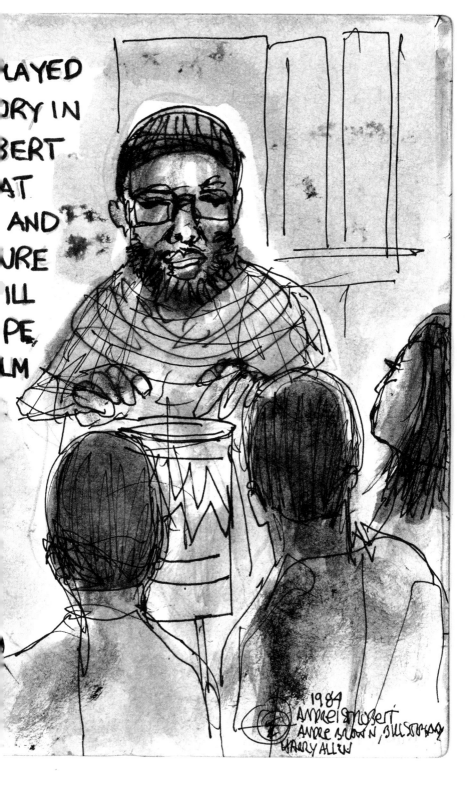

BABA THE GREAT DICK GREGOR
WAS SOMETHING ELSE. HE
WAS A FIREBALL OF ENERGY
WE ALWAYS WOULD RUN INTO
EACH OTHER IN DALLAS AT
CHERYL SMITHS DONT BELIEVE
THE HYPE BOWLING
FUNRAISERS N ON STOP
DROPPIN SCIENCE AND
JOKES. HE WAS THE FIRST
COLLEGE LECTURER I ATTENDED
AT ADELPHI. HE TURNED US
STUDENTS OUT IN 1983. I
TWISTED ANKLE ON STAGE AT
HOUSE OF BLUES AND BABA OG
WAS THERE MASSAGING MY ANKLE
IN A CONCOCTION IN A BUCKET
I WAS LIKE... HE WAS LIKE
SHH! HOLD, BE STILL....

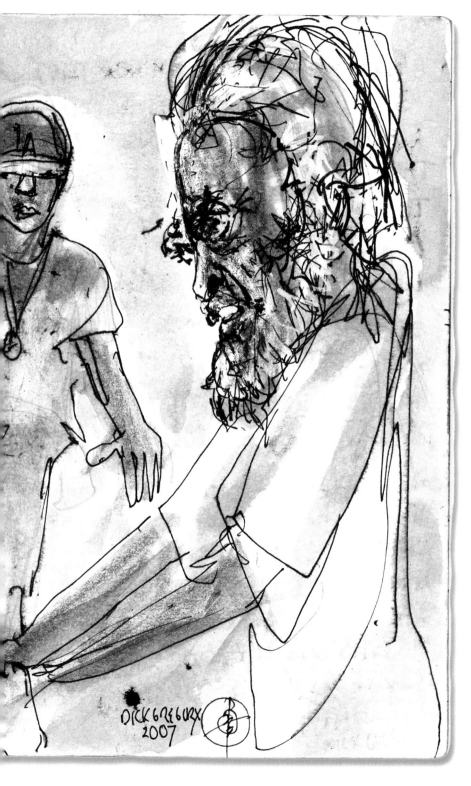

DICK GREGORY
2007

I USED TO LOVE VISITING THE PIO[...]
GREATS AND THE RHYTHM AND BLUE[...]
FOUNDATION GATHERINGS AND BANQU[...]
THESE EVENTS ALSO GIFTED
THE ARTISTS WITH
ASSISTANCE . HOSTS
LIKE SMOKEY ROBINSON
AND JERRY BUTLER SO
AWESOMELY GAVE MANY
THE FLOWERS THEY SO
DESERVED AS THEY MC'D

SIR ISAAC HAYES CALLED
ME OVER TO TAKE A PIC
WITH HE , MS MARY WILSON
AND CHARLIE FUQUA
MY HAT BILL OBSCURED
MS WILSON FACE, SHE SAID
`BOY IF YOU DONT TURN THAT HAT'
THAT HAT! DONT UPSET A GO[...]

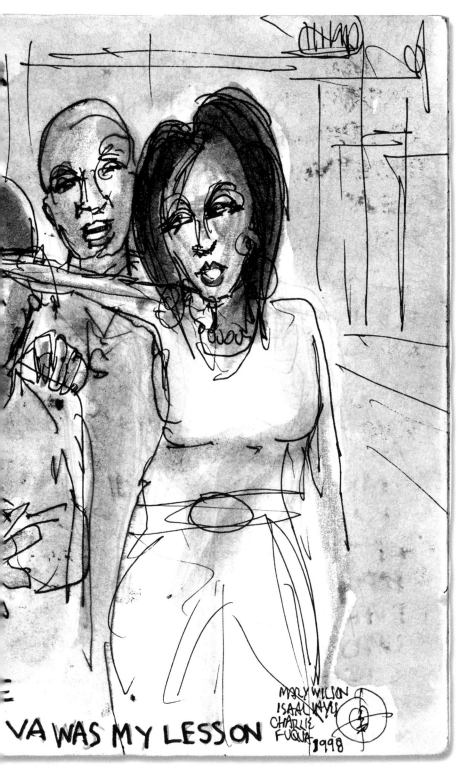

VA WAS MY LESSON

MARY WILSON
ISAAC HAYES
CHARLIE
FUQUA 1998

I VISITED MIKE TYSON
TWICE WHEN HE WAS
INDIANA PRISON AND P
HAD MY MOST INTELLECTUA
CONVERSATIONS EVER UPO
A ONE ON ONE MIKE WAS
GRACIOUS AND THE TIME W
FULL AND SOLID. MIKE HAD
JUST GOTTEN THE MAO TSE
TUNG TATTOO ON HIS ARM
ALSO MIKE WAS CONCERNED
ABOUT ALL OF THE BLACK
MIGRATION INTO THE
USA CITY OF ATLANTA
HE THOUGHT THE
POPULATION SHOULD BE
EVERYWHERE AS
OPPOSED TO
CONCENTRATED IN ONE
AREA WHERE IT COULD BE
EXPLOITED.

MAO

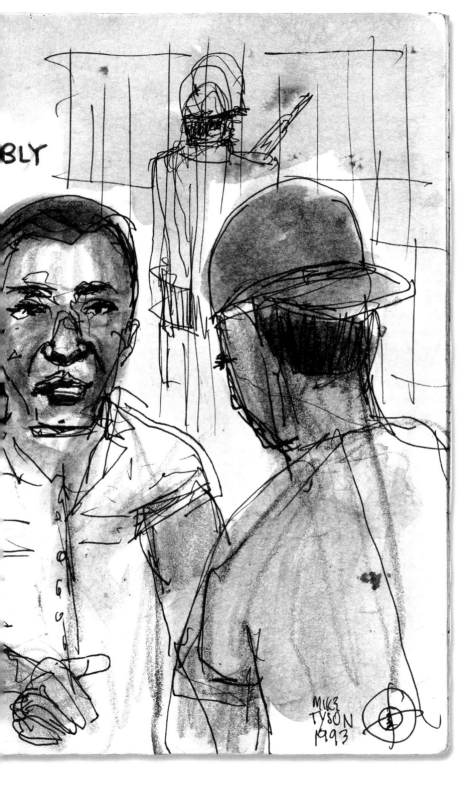

BLY

MIKE
TYSON
1993

THE DAY I RECORDED WITH THE LE
IN GAINESVILLE FLORIDA AND MUSIC
GET TO THE HOUSE AND HIS WIFE
THINNEST CIGARETTE I EVER SEEN
WE WALK INTO A BACK ROOM AND
MS DIDDLEY SHOUTS
`BOWWW' A YOUNG
MAN NAMED CHUCK
WANNA MEET YOU

HE'S IN BED
WATCHING TV
HEALING FROM
BURNS FROM A
CURTAIN FIRE
SHOWING ME
WHERE THEY TOOK
SKIN TO PUT ON
HIS HANDS I
WAS LIKE OK
MS BO CALLED
"BOWWW' A FEW MORE
TIMES

ARY BO DIDDLEY. I WAS LECTURING
SCOTT FREE SAID COME ON BY. I
GREETS ME WITH THE LONGEST

NEVER DROPPIN THAT LONG
CIGARETTE. HE GETS UP
AND GOES ACROSS THE
HALL TO HIS STUDIO
PLAYED A TRACK THAT
SOUNDED LIKE 50 THINGS
HAPPENING AT ONCE. I
DROPPED VOCALS
ON IT....

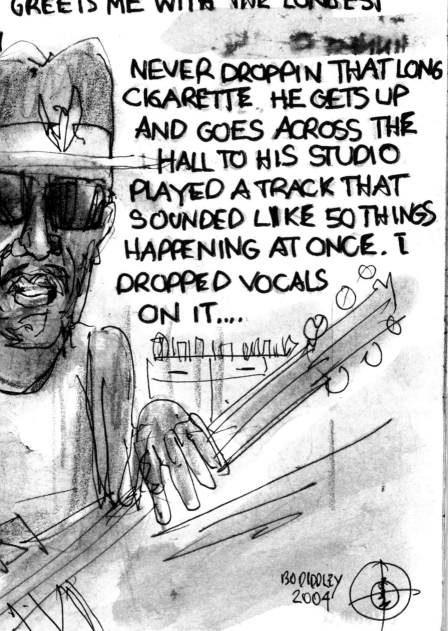

BO DIDDLEY
2004

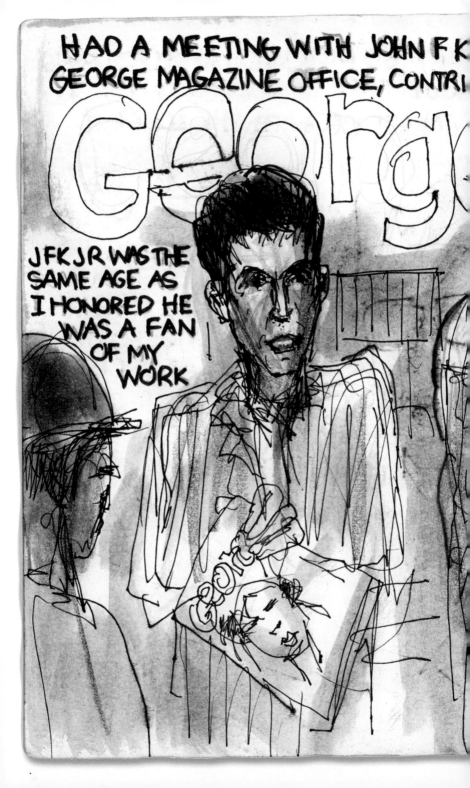

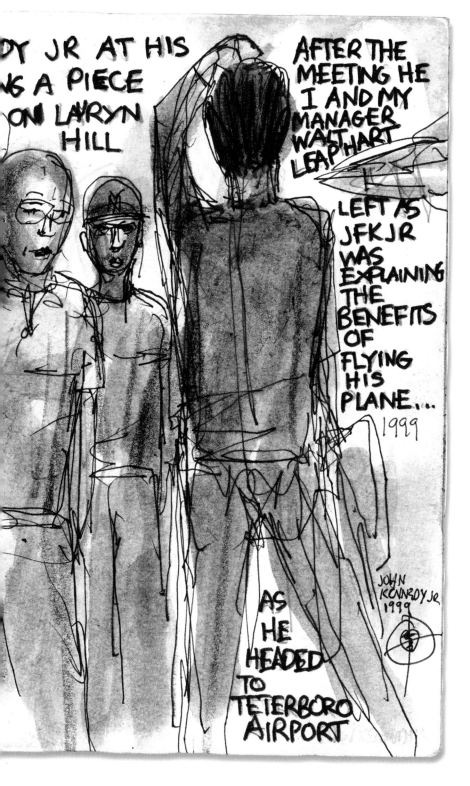

FIRST TIME MEETING OPRAH
WINFREY WAS IN CHICAGO AT
HER HARPO STUDIOS ON THE
TAPING OF A SHOW THAT NEVER
AIRED.
SHE WAS CORDIAL AS SHE
VISITED US BACKSTAGE
AND SEEMED TO KNOW
HARRY ALLEN VERY
WELL. I WAS LIKE 'YO
HARRY WHATS UP WITH
THAT? YEARS LATER
OPRAH WAS DANCING IN
THE FRONT ROW AT OUR
ROCK AND ROLL HALL OF FAME
INDUCTION IN 2013 TO
FIGHT THE POWER

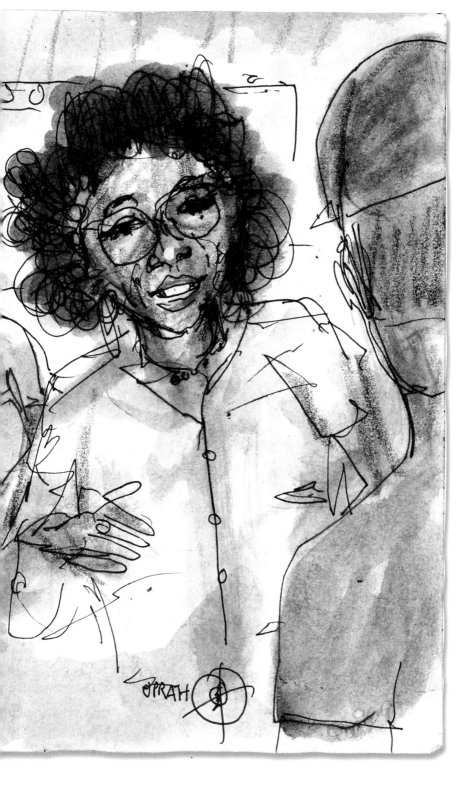

I DON'T RECALL EVER MEE[TING]
DEBORAH HARRY FROM [THE]
ROCK AND ROLL FAME P[ERFORMANCE]
BUT, HOWEVER I THINK I DI[D]
BACKSTAGE PROPHETS OF RAG[E]
PALLADIUM PERFORMANCE IN LO[S]
ANGELES, BACKSTAGE A BUSIN[ESS]
MANAGER AND THIS WOMAN WE[RE]
MEETING FOLK. A BRUNETTE W[ITH]
A HAT WAS INTRODUCED AS
'DEBORAH' LATER ON I WAS
ASKING MYSELF WHEN I LINED
ALL UP .. WAS THAT DEBBIE
HARRY? LOL I STILL GIVE HER
PROPS FOR THAT FLOW ON
RAPTURE.

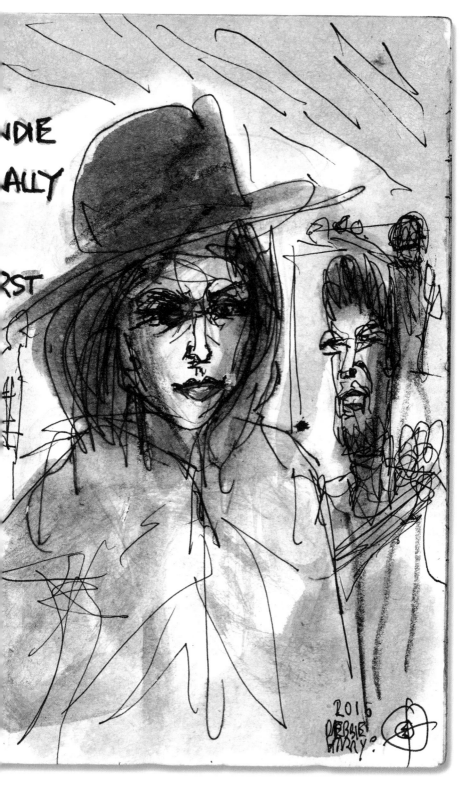

AT AIR AMERICA BOTH FATHER AN
FATHER THE GREAT MELVIN VAN
HIS SON MARIO VAN PEEBLES
WERE INTERVIEWED AT THE
STATION PROMOTING THEIR
LATEST FILM

AFTERWARDS MYSELF AND PAL
KYLE-JASON WENT ACROSS TO
34TH STREET TO GET SUSHI.
MELVIN WAS INSIDE. WE WERE
INVITED TO SIT AND CHOP IT UP
WITH HIM. I'M EATING SOME RICE
WITH MY CHOPSTICKS.. HALFWAY
THROUGH OG VAN PEEBLES TAKES
MY BOWL AND PROCEEDS TO
SCHOOL ME ON HOW TO EAT WITH
THEM PROPERLY. FOR AWHILE! ALL
GOOD AS KYLE LOOKED ON
STUNNED AND HILARIOUSLY....;

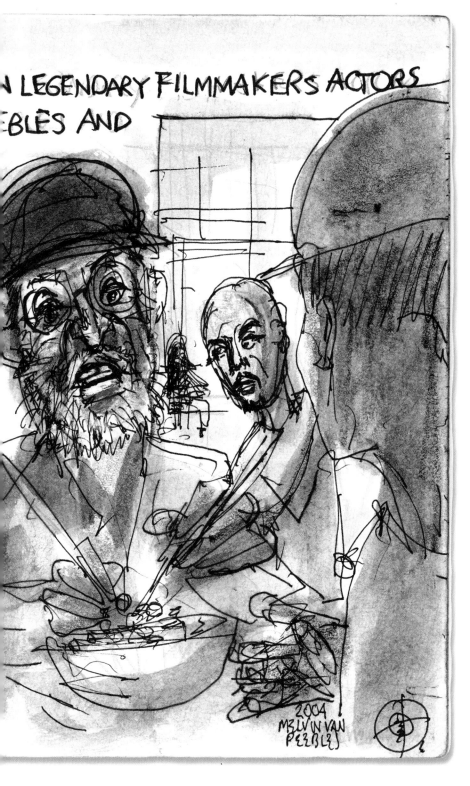

THE TIME MY MANAGER MR WALT
GREENROOM PERFORMANCE WITH
ROBIN WILLIAMS. I WORKED WITH BI
IN THE CREATIVE COALITION
INVITED TO A NYC READING
WORKS OF PROTEST IN ART
THEATER AND FILM. I
TO READ ALLEN GINSBERGS
'HOWL'. BACKSTAGE IN THE
GREEN ROOM, ROBIN WAS
GOING IN ON ALEC BALDWIN
OR ALEC WAS SHOWING HE
COULD GO JOKE FOR
JOKE, SNAP
FOR SNAP,
ROBIN WAS
REALLY THAT
DUDE.. PSYCHO
MANIC NON
STOP WITH
IMPERSONATIONS
AND ALL WE
HAD A BEST
SEAT IN THE
HOUSE...

THE EAST COAST WEST COAST
TIME OF HYPED BULSHT, WIT
STUPID IN FACT THE FLAM
MEDIA IN NEW YORK AND

AFTER TUPAC SHAKUR WAS MURD
IN SEPTEMBER 1996 IN LAS VEGAS
I RECALL MYSELF AND HIP HOP
PIONEER AFRIKA BAMBAATAA
OUTSIDE OF A HIP HOP EVENT AT A
CLOSING OF A VENUE NAMED
TRAMPS POST THE RECENT
KILLING OF NOTORIOUS BIG
SMALLS TELLING HIM
DONT GO TO LA TO
PROMOTE HIS NO WAY
OUT ALBUM.. HE SAID
HE HAD TO.. WE BOTH
LOOKED AT HIM
LIKE DUDE WHAT ?!

NG IN THE 1990s WAS A RIDICULOUS
ERY REAL **LIVE** OUTCOMES.
VERE BEING FUELED BY THE
ANGELES... SO I THOUGHT

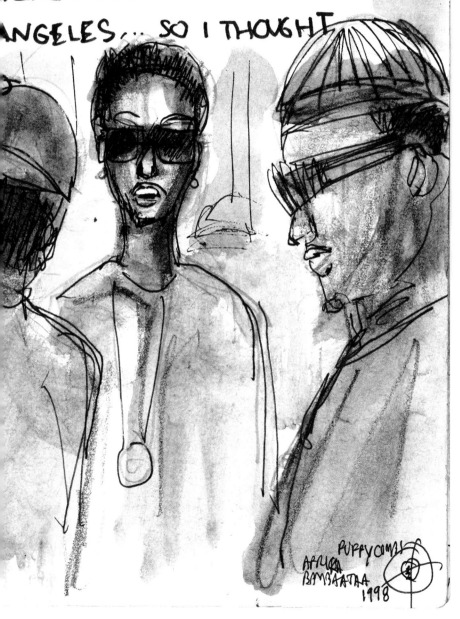

PUFFY COMBS
AFRIKA
BAMBAATAA
1998

ONE TIME WALKING IN SOHO AR
INTO MY BRO Q-TIP FROM A TRIBE
JUST TALKING ON A CORNER THERE
ABOUT THINGS IN THE WORLD AND
ALL OF A SUDDEN THIS 7 FOOT BRO
WALKS UP TO US . IT WAS BRIAN
WILLIAMS THE NBA CENTER AND
HE JOINED THE CONVERSATION

HE ASKED IMPORTANT
QUESTIONS THAT WERE
ON HIS MIND AND
WE COULD TELL IT
RANG HEAVY ON HIM

TIP AND I BRIGHTENED
THE CONVO. I
RECALLED TALKING
TO HIM WHILE HE
WAS IN COLLEGE IN
ARIZONA. HE MOST
RECENTLY CHANGED
HIS NAME TO
BISON DELE AND
WON A CHAMPIONSHIP WITH
THE CHICAGO BULLS . . .

EW YORK CITY, I HAPPENED TO RUN
E D QUEST OF ALL PEOPLE. WE WAS

SOHO

BUT HE SEEMED
TROUBLED IN WAYS
.. NOT LONG AFTER
IN THE NEXT DECADE
HE WAS CONSIDERED
MISSING SUSPICIOUSLY
IN THE SOUTH PACIFIC
SOME SAY
MURDERED
SOME SAY
SUICIDE AS HIS
BOAT AND
SUSPECTS WERE
FOUND...
BUT NO
BISON...

QTIP
BISON DELE
2000

FIRST TIME I MET SHAQUILLE O'N[
RED CARPET GALA
SAYING "EXCUSE ME MR D" THEN
THE NEXT
SECOND
WE BOTH
HEARD A
TREMENDOUS
UP ROAR
OF THE
CROWD WTF.
IT WAS
MARILYN
MANSON AND
ROSE
McGOWAN

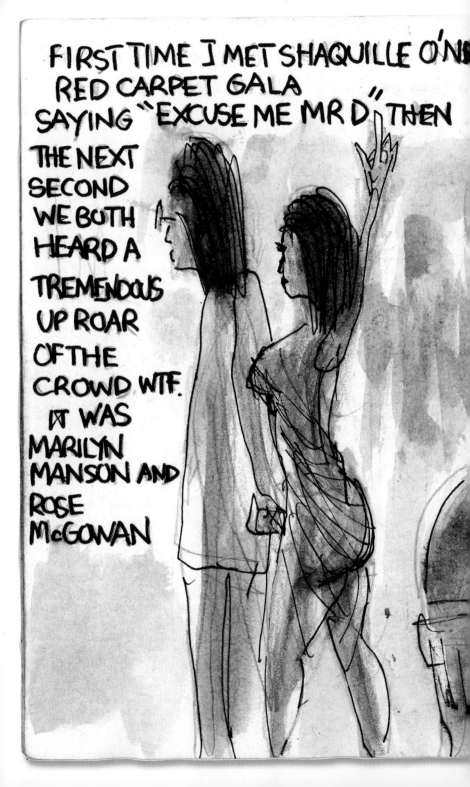

G SHAQ AS A PRO WAS AT A MTV
HE CAME UP BEHIND ME

1998
SHAQ
ROSE MC GOWAN
MARILYN MANSON

GROWING UP IN ROOSEVELT LI
PROGRAM ALONG WITH MY SIST
UNIVERSITY CAMPUS. 2 THINGS H
THAT SUMMER. 1. I MADE UP MY
MIND AT 12 ADELPHI WAS THE
ONLY COLLEGE FOR
ME. 2. THE
PROGRAM ALSO
HAD THIS LOUD
KID WHO JUST
MOVED TO
ROOSEVELT
FROM BROOKLYN...
TELLING NON STOP
JOKES AND MUHAMMAD ALI AND
HOWARD COSELL IMPERSONATIONS
I TRIED TO SIT AS FAR AWAY FROM
THIS DUDE AS POSSIBLE. THE GUY
WAS EDDIE MURPHY WHO WAS LAT
A PEER WHO WOULD COME COOL TO
ROOSEVELT PARK IN SHOES ALWAYS
TALKING TO THE GIRLS ON THE
HANDBALL COURT...

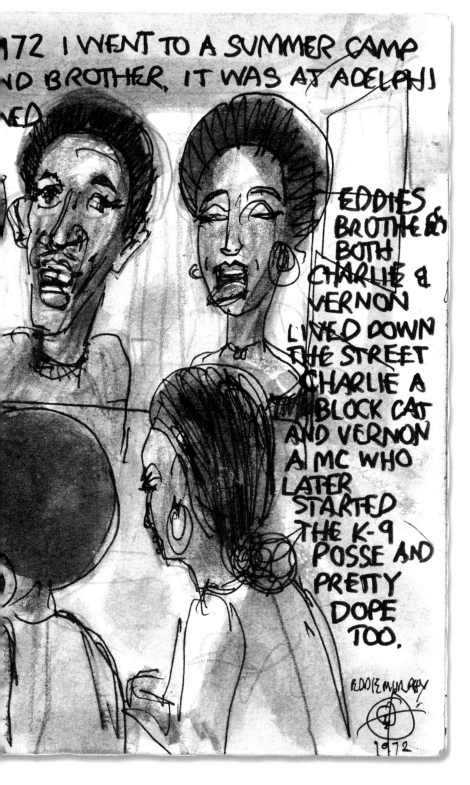

1972 I WENT TO A SUMMER CAMP
ND BROTHER, IT WAS AT ADELPHI
NED

EDDIES
BROTHERS
BOTH
CHARLIE &
VERNON
LIVED DOWN
THE STREET
CHARLIE A
BLOCK CAT
AND VERNON
A MC WHO
LATER
STARTED
THE K-9
POSSE AND
PRETTY
DOPE
TOO.

EDDIE MURPHY

1972

SPECTRUM WAS THE
MOST RESPECTED
MOBILE DJs ON
LONG ISLAND EVER
BASED IN
ROOSEVELT
HANK SHOCKLEE
AND HIS BROTHER
KEITH FORMED IT
AT THE ROOSEVELT
YOUTH CENTER AS
WRYC. GRIFF WAS A DJ
I GOT RECRUITED IN 1979.
BEFORE I BECAME
A MC FOR THEM IT
WAS SORTA OPEN
MIC AND OCCASIONALLY
EDDIE MURPHY WOULD
GRAB THE MIC AND
TELL JOKES AND
IMPERSONATIONS OVER MUSIC..
IT WOULD BE MANIC ALL
THE WAY WHEN MURPH WOULD EVEN
STOP THE SPINNING RECORD ...

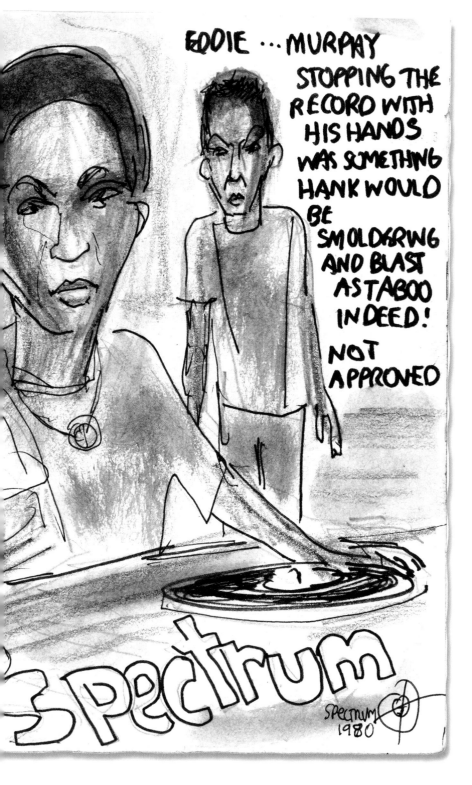

SAY WHAT YOU WA
SAY ABOUT MS A
BEING A DIVA...
CHOOSES TO FLO
MODE DEPENDING
SITUATION... BUT
REMEMBER WORK
A FULL DAY WITH
HER LOBBYING I
WASHINGTON DC
FRONT OF CONGRES
ALL DAMN DAY
REFORM FOR THE
ARTS. SHE WAS
GRINDING MORNIN
TO NIGHT IN WHAT
LOOKED LIKE
UN COMPROMISING SHO
IN THE HEAT TOO...SHE
TROOPER I GARNERED M
RESPECT FOR THAT DAY
GAVE THE BEST WHAT SHE HA

I MET MS [
ATLANTA WHEN H
ME AT HER
FAMOUS CHIC
AND WAFFLES
RESTAURANT S
OWNED WITH B
WINANS. MOST
RECENTLY IN
RE MET MS KN
THE KENNEDY CE
IN DC. IN THE E
I SAID HELLO MS
AND SHE AND HER
PEOPLE SAID HELL
CHUCK', I MELTED.
THE FACT THAT MS
GLADYS SAID MY N
WAS ENOUGH ...

 GLADYS KNIGHT 2015

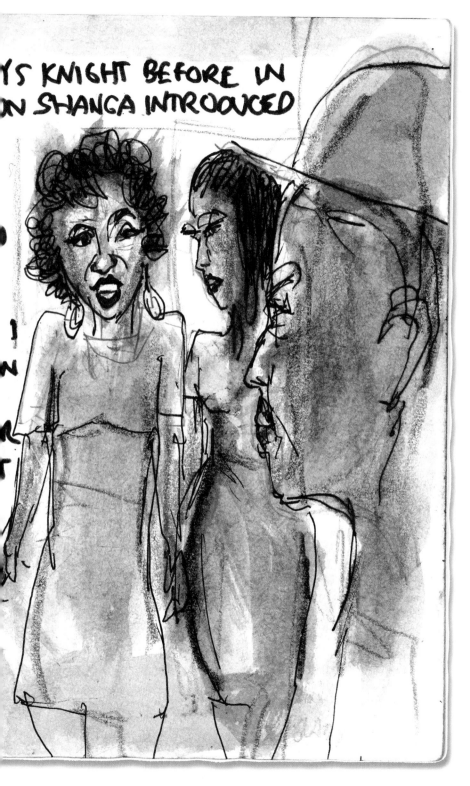

ONE NEW YEARS EVE I WAS IN
LAS VEGAS.. MIKE TYSONS HOME
AND IT WAS A SMASH
OF A PARTY EVENT..
I SAT IN THE KITCHEN
AND MIKE WAS
STANDING BY HIS
REFRIGERATOR SAYING
'SAY SOMETHING TO
STEVIE!' SEATED
WERE STEVIE WONDER
AND NARADA MICHAEL
WALDEN... STILL I
COULDNT MUSTER
A WORD. I NEVER
FIGURE WHAT TO
SAY AROUND MR
STEVIE WONDER... I SAT THERE
MUTE AS A MF AT THAT
KITCHEN TABLE ...

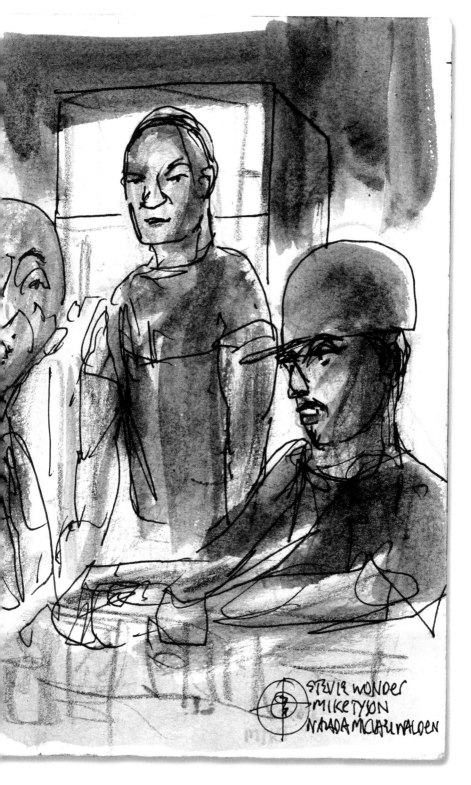

STEVIE WONDER
MIKE TYSON
NARADA MICHAEL WALDEN

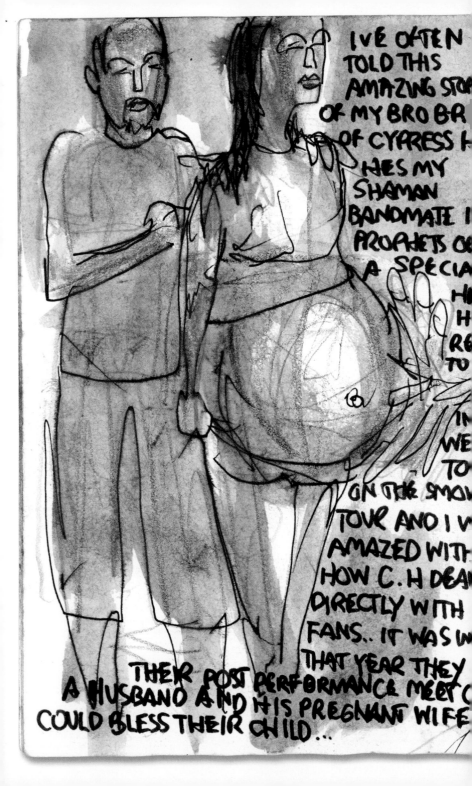

I'VE OFTEN TOLD THIS AMAZING STO[RY] OF MY BRO BR[...] OF CYPRESS H[...] HE'S MY SHAMAN BANDMATE [...] PROPHETS O[...] A SPECIA[...] H[...] H[...] RE[...] TO[...]

I[...] WE[...] TO[...] ON THE SMO[...] TOUR AND I W[...] AMAZED WITH[...] HOW C.H DEA[...] DIRECTLY WITH[...] FANS.. IT WAS W[...] THAT YEAR THEY[...] THEIR POST PERFORMANCE MEET [...] A HUSBAND AND HIS PREGNANT WIFE COULD BLESS THEIR CHILD ...

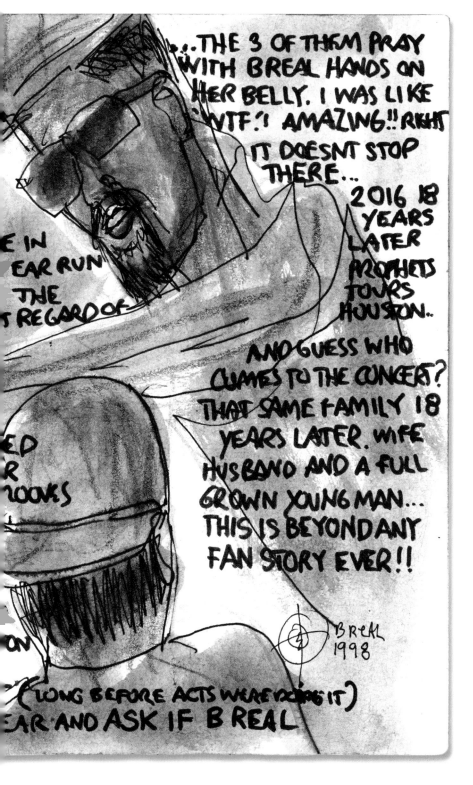

EASIER FOR THE MEDIA TO
TALKING ABOUT THE PERSON W
OF THE 1990' EAST WEST CULMINAT
OF TUPAC SHAKUR AND NOTORIOUS
BEEN MUCH WORSE WITHOUT THE

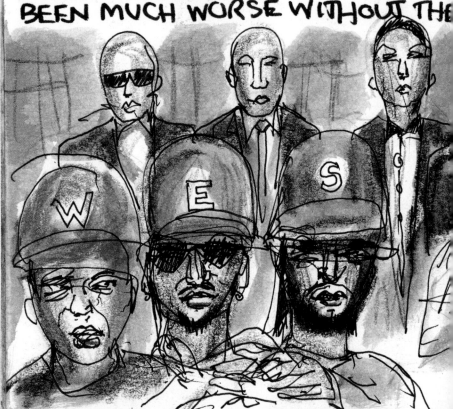

MINISTER LOUIS FARRAKHAN OPE
CHICAGO. SCORES OF RAPPERS WOU
RECEIVE ADVICE ORGANIZATIONAL
THE FORTITUDE OF THE NATION OF
OUT MANY OF THESE FIRES AND D

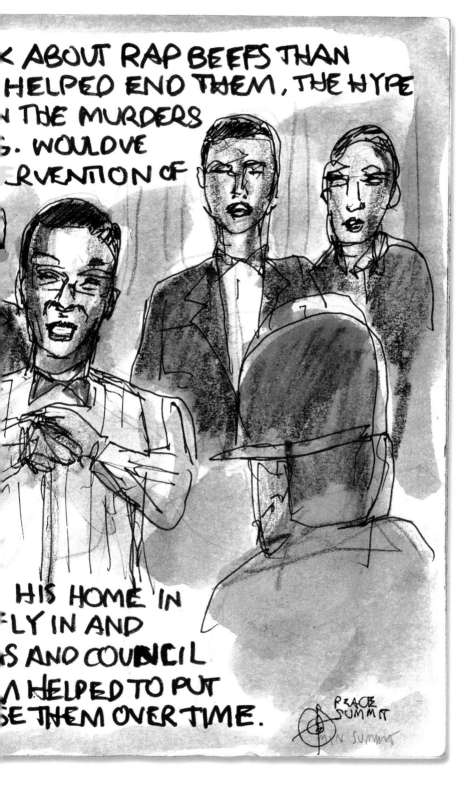

K ABOUT RAP BEEFS THAN
HELPED END THEM, THE HYPE
N THE MURDERS
G. WOULDVE
RVENTION OF

HIS HOME IN
LY IN AND
S AND COUNCIL
HELPED TO PUT
SE THEM OVER TIME.

PEACE
SUMMIT
N SUMMIT

MALIK FARRAKHAN AKA TONY K W
MENTOR AND CONFIDANT. TOUR RIC
BUDDY AND PE SECURITY WHILE I E
ACROSS MAP. 1992 HE STARTED WITH
AND HAD BEEN A
PRESENCE FOREVER
WITH US. I DONT
KNOW HOW I CAN
MEASURE HIS
IMPORTANCE AND
GUIDANCE

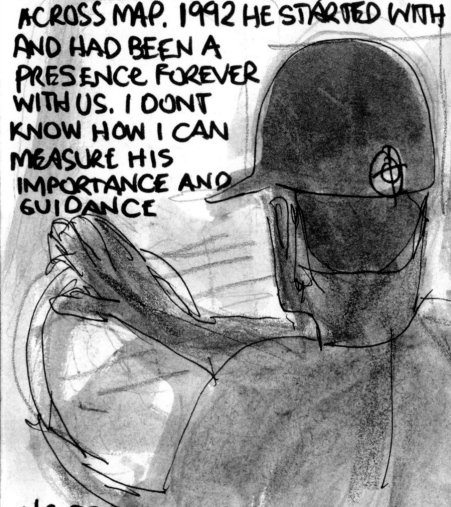

HIS RESUME IS LOADED.. PLAYED I-
AND AFL IN THE 1960S WITH HIS BRO
THEN MOVED INTO FILMS LIKE THE
HELL UP IN HARLEM, REPORT TO THE O
AND DAUGHTERS OF THE DUST...

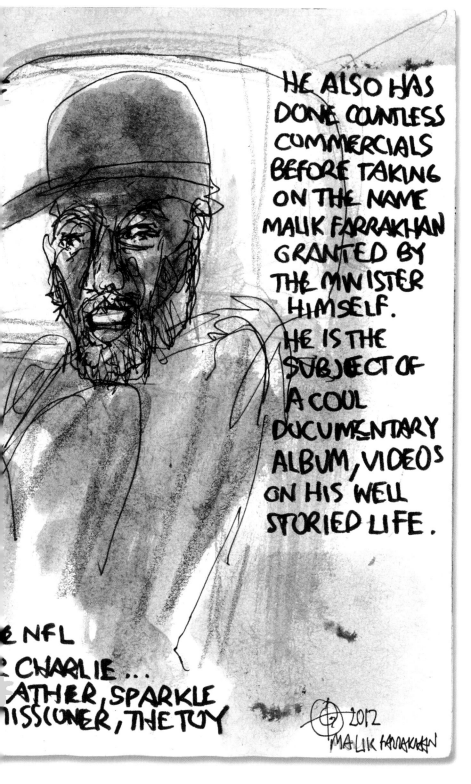

HE ALSO HAS DONE COUNTLESS COMMERCIALS BEFORE TAKING ON THE NAME MALIK FARRAKHAN GRANTED BY THE MINISTER HIMSELF.
HE IS THE SUBJECT OF A COOL DOCUMENTARY ALBUM, VIDEOS ON HIS WELL STORIED LIFE.

E NFL
CHARLIE ...
ATHER, SPARKLE
IISSIONER, THE TOY

2012
MALIK FARRAKHAN

HIP HOP ARTISTS BARELY GET THEIR
COMMUNITY EFFORTS.. ITS MAINLY
THE NEGATIVE STUFF BY THE MEI
WE TOOK A TOUR WITH SEVERAL NE
INTO CLEVELAND. THAT DAY WE AL
WASHED CARS AT NBA NEW YORK
KNICK LEGEND CHARLES OAKLEY
CAR WASH.... IT WAS SOMETHING
HAVING THE
6-9 250
POUND
OAK...

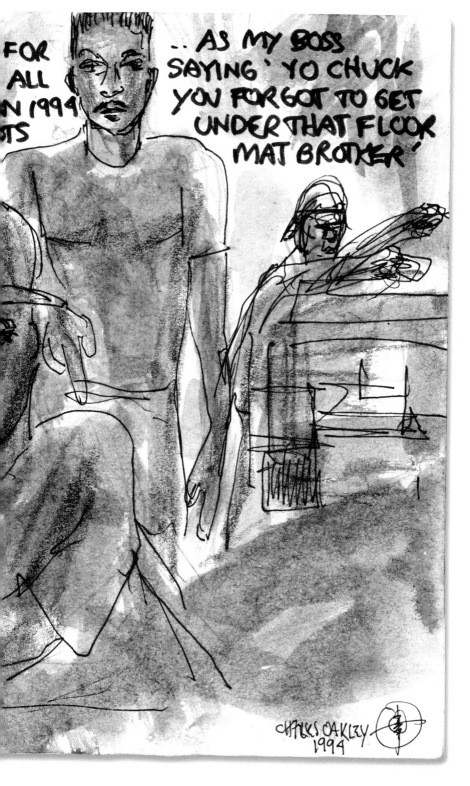

AUNTIE MS MAVIS STAPLES WILL
MUSIC COLLABORATION. FIRST OF ALL
1960s AND THE STAPLES SINGERS WAS

I HAD THE HONOR OF MEETING
MS YVONNE AT A STAX RE
IN MEMPHIS. I TOLD
PAL KYLE JASON
WRITTEN A INCREDIBLE
FOR HER. SHE AND
HAD FLEW TO ROOSEVELT
LI TO CUT IT..
 SHE NEVER USED
 THE SONG BUT
 HER VOCALS
 WERE IN
 THE
 TAPES
 ON
 HO.
KYLE THEN FOUND A
WAY TO PULL THEM OUT
YEARS LATER. THE
PRODUCTION TEAM OF
DIVIDED SOULS THEN
CRAFTED A AMAZING
SONG 'GIVE WE THE
PRIDE FROM THE VOCALS ...

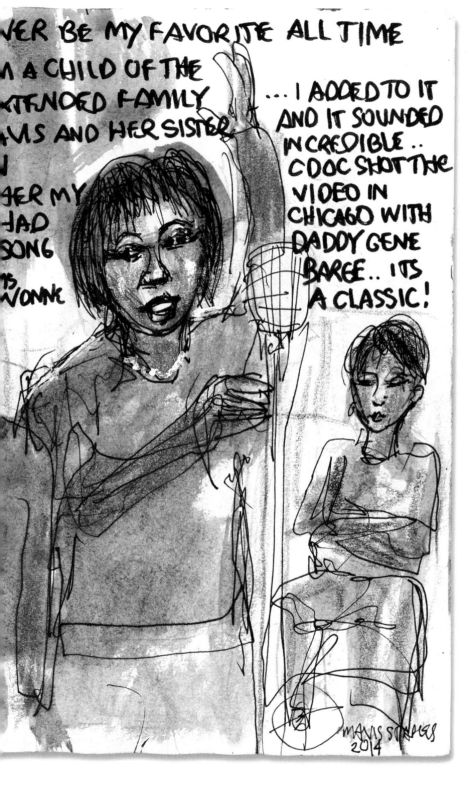

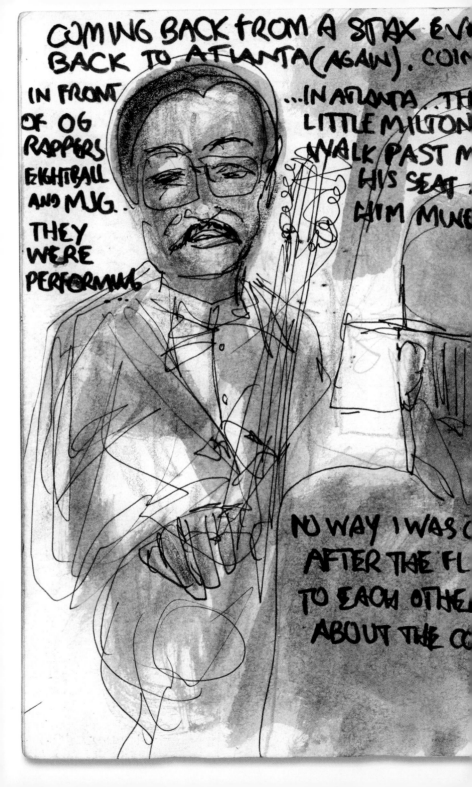

COMING BACK FROM A STAX EV[...]
BACK TO ATLANTA (AGAIN). COI[...]

IN FRONT
OF OG
RAPPERS
EIGHTBALL
AND M.J.G. ..
THEY
WERE
PERFORMING

...IN ATLANTA .. TH[...]
LITTLE MILTON[...]
WALK PAST M[...]
HIS SEAT. [...]
HIM MINE[...]

NO WAY I WAS C[...]
AFTER THE FL[...]
TO EACH OTHE[...]
ABOUT THE CO[...]

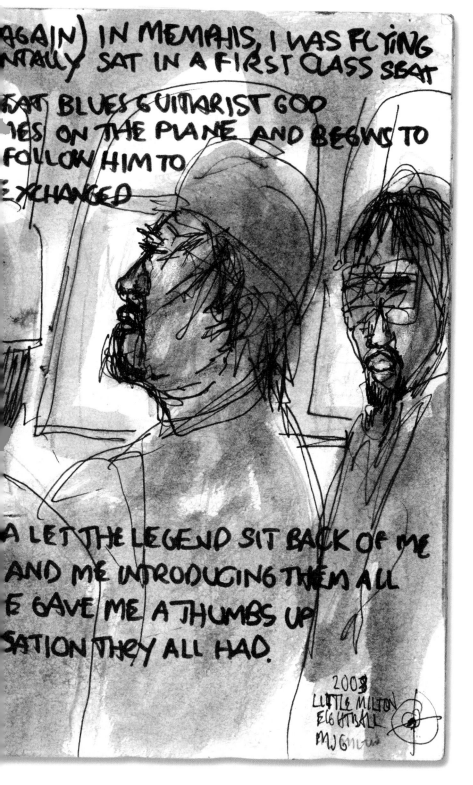

AGAIN) IN MEMPHIS, I WAS FLYING
NTALLY SAT IN A FIRST CLASS SEAT

EAT BLUES GUITARIST GOD
MES ON THE PLANE AND BEGINS TO
FOLLOW HIM TO
EXCHANGED

A LET THE LEGEND SIT BACK OF ME
AND ME INTRODUCING THEM ALL
E GAVE ME A THUMBS UP
SATION THEY ALL HAD.

2008
LITTLE MILTON
EIGHTBALL
MJGnew

WAS DOING A TV SPECIA

OUT AND THOUGHT MY

LED HER PRODUCTION TE

FILM ME OUTSIDE OF

NASSAU COLISEUM. THA

STARTED A MUTUAL RES

AS SHE INTERVIEWED

WELL ON MUSIC MEANIN

AND ITS POWER ON POL

A FEW YEARS LATER I W

ASKED TO COLLABORATE O

A SONG BY SUPER MUSIC

WUNDERKIND RUMMER

STEVE JORDAN .. THE

SONG

WAS INTERRUPTED BY THE

PROMOTION WISE BUT STA

AS A POWERFUL PIECE ..

WE ARE ALWAYS A TEXT

THE WORLD THAT WE SE

...ITH SHERYL CROW WHO REACHED
...T OF VIEW WAS WORTHY. SHE
...TO

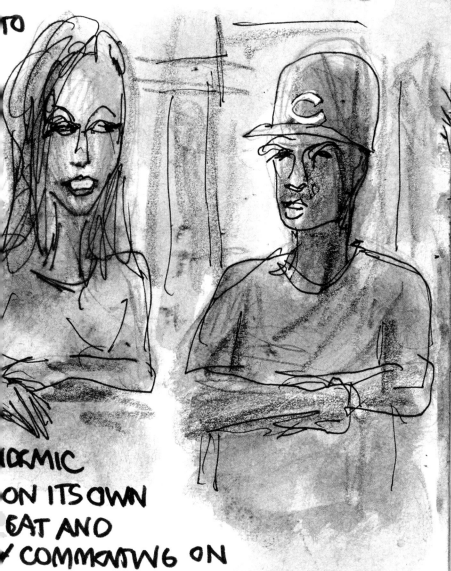

...IDEMIC
...ON ITS OWN
...EAT AND
...Y COMMENTING ON
...EEDING CHANGE....

SHERYL
CROW

HELLO CHUCK D' WELCOME TO DEAT[H]
LABEL ... IN 1999 I VISITED MUM[IA]
THE GREENE COUNTY PA PRISON
FOR AWHILE, AND MUMIA SHOWED
BLISTERS... HE HAD TO WRITE WIT[H]
ENCASING. JUST THE INK
TUBE. IT WAS DISTURBING
AND I VOWED TO KEEP
HIS FIGHT IN CURRENCY
ALSO I FOUND THAT IT
WAS THE SAME
SOUTHWEST PA JAIL THAT
WAS HOLDING BLACK
PANTHER RUSSELL SHOATZ
AND RAPPERS COOL C
AND STEADY B

OW! IT SURE WASNT THE RECORD
3U JAMAL WHO WAS IMPRISONED AT
HELL. WE TALKED
HANDS AND
PEN

MUMIA ABU
JAMAL
2000

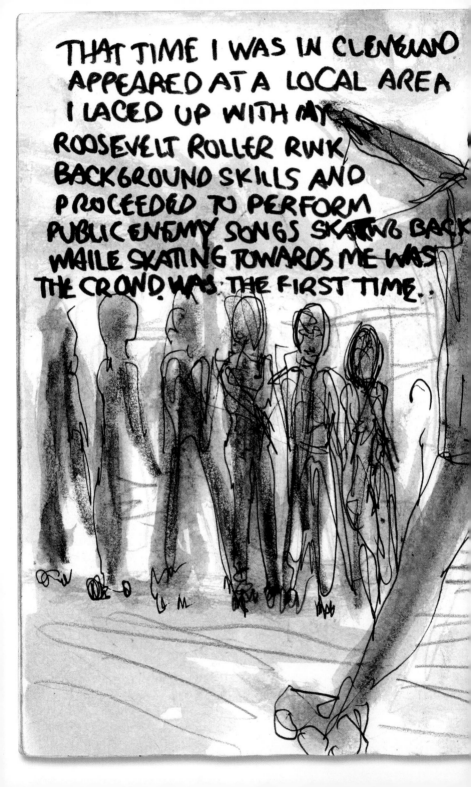

THAT TIME I WAS IN CLEVELAND
APPEARED AT A LOCAL AREA
I LACED UP WITH MY
ROOSEVELT ROLLER RINK
BACKGROUND SKILLS AND
PROCEEDED TO PERFORM
PUBLIC ENEMY SONGS SKATING BACK
WHILE SKATING TOWARDS ME WAS
THE CROWD. WAS THE FIRST TIME..

MOTING AND SPEAKING AND I
ER RINK, WHEN IN ROME... YEAH
... ANYBODY WITNESSED
SUCH A PERFORMANCE
PROBABLY ALSO THE LAST TIME..

1996
CLEVELAND
ROLLER
RINK

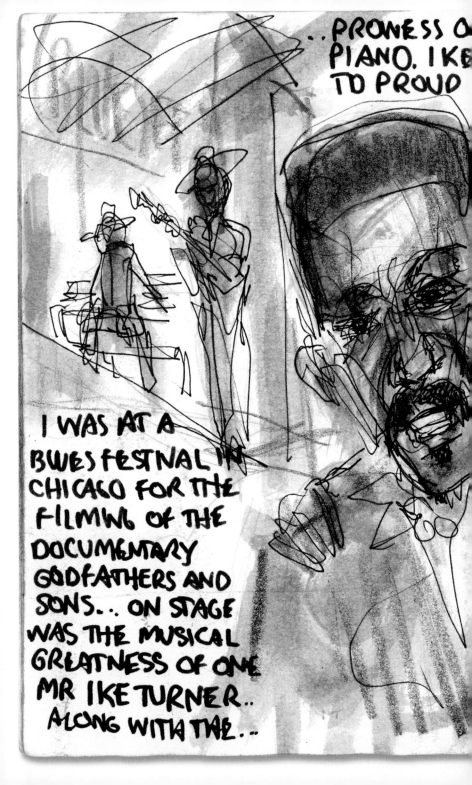

.. PROWESS O
PIANO, I KE
TO PROUD

I WAS AT A
BWES FESTINAL IN
CHICAGO FOR THE
FILMING OF THE
DOCUMENTARY
GODFATHERS AND
SONS... ON STAGE
WAS THE MUSICAL
GREATNESS OF ONE
MR IKE TURNER..
ALONG WITH THE...

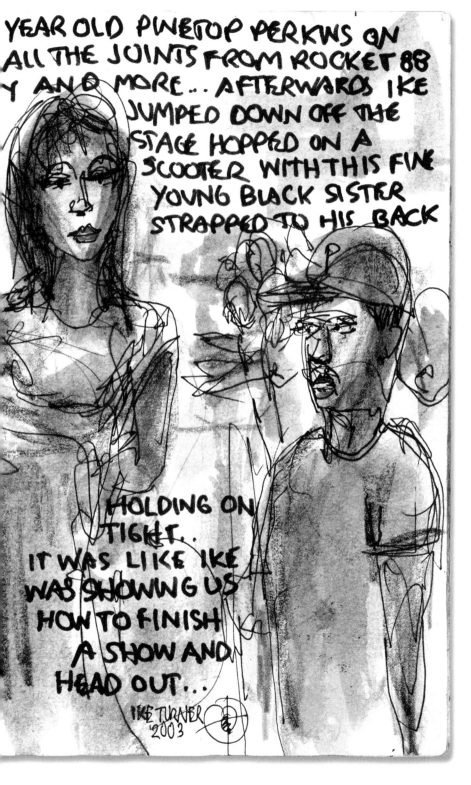

YEAR OLD PINETOP PERKINS ON
ALL THE JOINTS FROM ROCKET 88
Y AND MORE... AFTERWARDS IKE
JUMPED DOWN OFF THE
STAGE HOPPED ON A
SCOOTER WITH THIS FINE
YOUNG BLACK SISTER
STRAPPED TO HIS BACK

HOLDING ON
TIGHT..
IT WAS LIKE IKE
WAS SHOWING US
HOW TO FINISH
A SHOW AND
HEAD OUT...

IKE TURNER
'2003

AT THE TURN OF THE CENTURY, T
ESPECIALLY REGARDING THE DIS
UPON SIGNING WITH
ATOMIC POP, I WAS
CONSIDERED A
PIONEERING FIGHTING
GURU IN MP3
DELIVERY. I DID A
LOT OF KEYNOTES
IN 1999-2009

P
D
B
AU
NE
AE

NTERNET WAS THE BIGGEST DEAL
VTION OF MUSIC AND DATA.

Y
VED
VTED
A
IN
K FROM

0...

WE TALKED AND
SHOOK HANDS
BACKSTAGE AND
BRIEFLY TALKED
ABOUT THE
FUTURES....

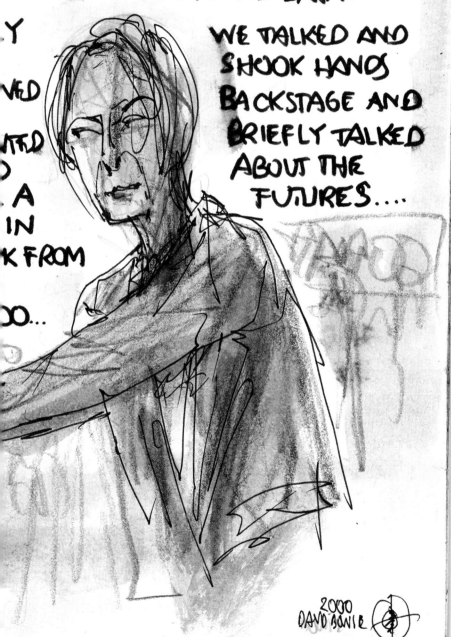

2000
DAVID BOWIE

PRINCE YES THAT PRINCE HA
PAISLEY PARK GROUNDS. I M
TRULY A COOL BOND IN LIKE N
I DO A SONG FOR HIS UPCOMIN
SONG 'UNDISPUTED WAS A EXPE
MIND BLOWING STORY THAT DAY W
WHEN WE GOT TO PAISLEY PARK M
PURPLE WAS HAVING A YARD SAL
ON ITS FRONT LAWN! AMPS
GUITARS, PRINCE SWAG AND
MEMORABILIA COMPLETE
WITH TAGS AND HIS HIGHNESS
HIMSELF GIVING DEALS
TO FOLKS... LIKE ILL GIVE
YOU A BARGAIN ON THIS
KEYBOARD. CRAZIER
THAT CHARLIE MURPHYS
PANCAKE BASKETBALL
STORY...

PRINCE 1999 PAISLEY

ACTUAL YARD SALE ON THE
PRINCE IN 1999 AND IT WAS
EDNESS.. PRINCE ALSO REQUESTED
AVE UN2 THE JOY FANTASTIC', THE
CE IN ITSELF BUT AGAIN THE

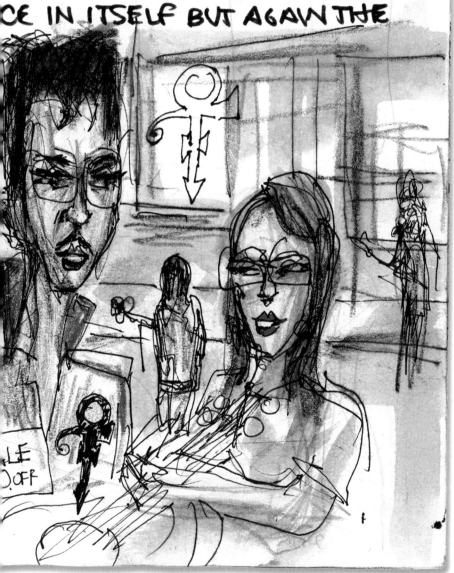

MY ONLY ENCOUNTER WITH MIKE JAX WA
BOTH STRANGE YET FUNNY. I WAS IN TOWE
RECORDS ON SUNSET LA EARLY 90'. I WAS IN
THE RACKS LOOKING AT MUSIC. I WALKED INT
THIS GUY I WENT LEFT HE WENT RIGHT .. VICE
VERSA.
COULDNT
GET PAST
EACH OTHER
HIS FACE
WAS
COVERED

MASKED UP. I
THOUGHT NO B
DEAL. LATER
WHEN I GO
TO THE
COUNTER
AFTER HE
LEFT
THE
CASHIER
SAID IT
WAS
MJ

THEN I
SAW A
ROLLS ROYCE
EXITING THE
PARKING
LOT ...

MICHAEL
JACKSON?

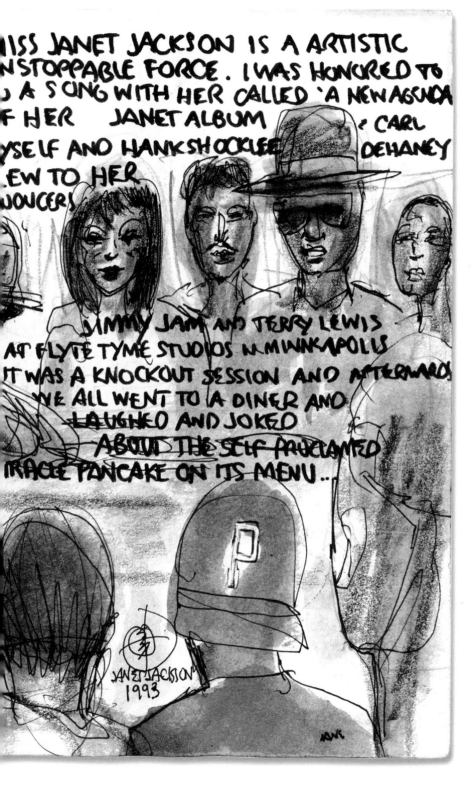

MISS JANET JACKSON IS A ARTISTIC
UNSTOPPABLE FORCE. I WAS HONORED TO
O A SONG WITH HER CALLED `A NEW AGENDA
F HER JANET ALBUM & CARL
YSELF AND HANK SHOCKLEE DEHANEY
EW TO HER
OUCERS

JIMMY JAM AND TERRY LEWIS
AT FLYTE TYME STUDIOS IN MINNEAPOLIS
IT WAS A KNOCKOUT SESSION AND AFTERWARDS
WE ALL WENT TO A DINER AND
~~LAUGHED~~ AND JOKED
~~ABOUT THE SELF PROCLAIMED~~
IRACLE PANCAKE ON ITS MENU ...

JANET JACKSON
1993

COMING OUTTA
ROOSEVELT LONG
ISLAND NY.. WE
HAD SOME CLEAR
HERO ENERGY
GROWING UP.. IN THE
70s FOR REAL. SPORTS WISE
IN FOOTBALL BALTIMORE
COLTS TIGHT END JOHN MACKEY
WAS A HALL OF FAMER AND SUPER
BOWL HERO.. BUT JULIUS DR J
ERVING WAS ALSO FROM THERE

MY MOM HAD THE ROOSEVELT COMMUN...
THEATRE AND WAS INSTRUMENTAL ON TH...
TOWN PARADE A COUPLE YEARS. ONE
YEAR DR J WAS THE PARADE MASTER O...
CEREMONIES. HE HAD JUST WON HIS
FIRST ABA CHAMPIONSHIP UP THE RO...
AT NASSAU COLISEUM FOR THE NY NET...
DR J CAME TO MY HOUSE FOR THE P...
CEREMONIES FOR A FEW MINUTE...

AS A 14
THIS EVE...
WAS MIN...
DR J IN
CRI...

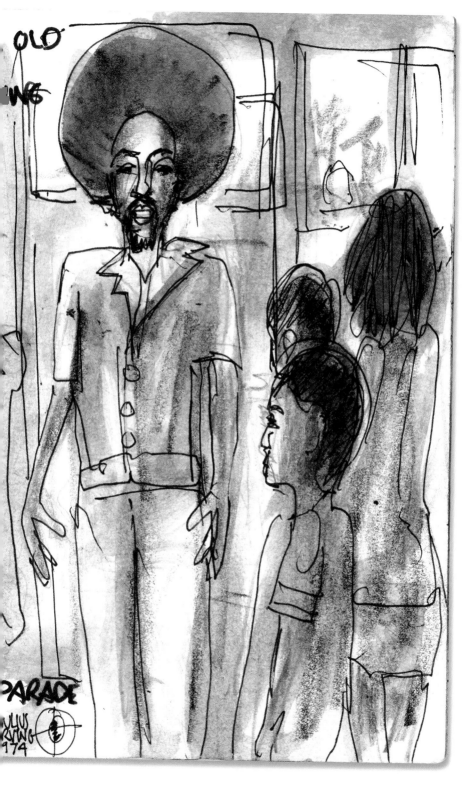

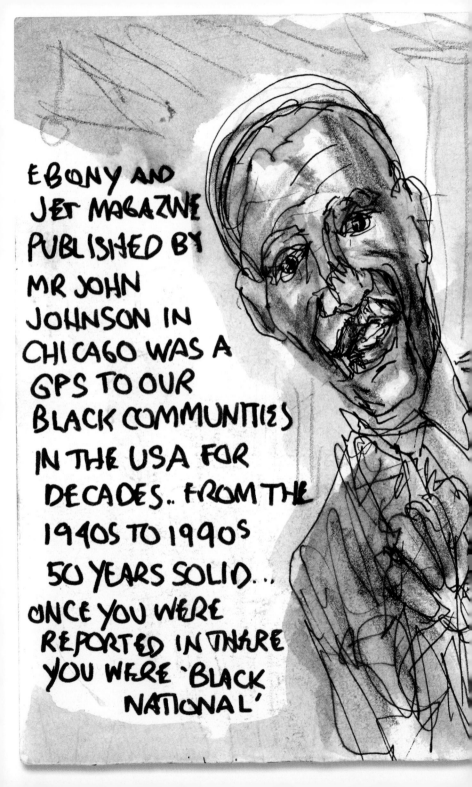

EBONY AND
JET MAGAZINE
PUBLISHED BY
MR JOHN
JOHNSON IN
CHICAGO WAS A
GPS TO OUR
BLACK COMMUNITIES
IN THE USA FOR
DECADES.. FROM THE
1940S TO 1990S
50 YEARS SOLID...
ONCE YOU WERE
REPORTED IN THERE
YOU WERE 'BLACK
NATIONAL'

ROY WILKINS WAS ALWAYS IN THERE
ONE YEAR THE ROOSEVELT
SCHOOL DISTRICT PTA INVITED
HIM TO SPEAK TO THE TOWN.
AFTERWARDS I SHOOK HIS HAND
HE TALKED TO ME AND OFFERED
ME A 'COOKIE'! HE WAS THE
VERY FIRST 'FAMOUS' PERSON
I INTERACTED WITH...

WOW
CELEB

1971
ROY WILKINS

COMING MOST LIKELY FROM A ST
BACK TO ATLANTA, I SAT NEXT T
COMPLETELY KNOCKED OUT SNOR
THE WINDOW... I DIDNT WANT TU
UP BUT I PRIDED IN THE FACT

MY BLACK MUSIC
AND ITS HISTORY.
SO I GET ENOUGH
NERVE AND TAP
HIM ON THE
SHOULDER AND
SAY 'I LOVE
EVERYTHING YOU'VE
DONE FOR US
MR DOMINO! HE
GROGGLY REPLIED BACK
IN THE NICEST WAY...
'I'M PERCY SLEDGE
SMILED AND WENT
BACK TO SLEEP AGAINST
THE WINDOW....

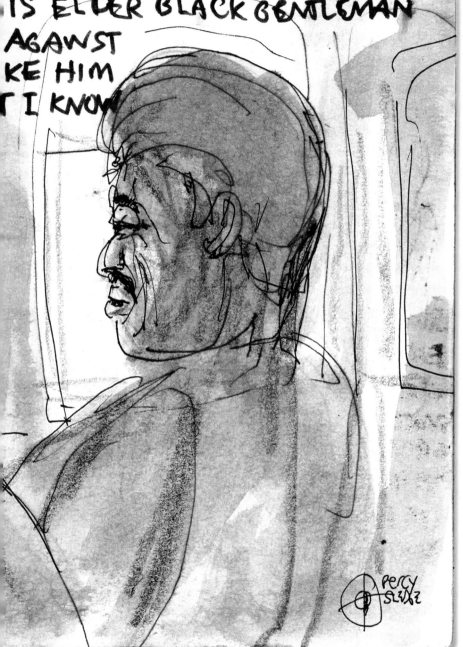

EVENT IN MEMPHIS HEADED
IS ELDER BLACK GENTLEMAN
AGAWST
KE HIM
T I KNOW

percy
SL3/2

I MET GINA BARGE WORKING ON
WHO WAS PRODUCING THE GODFATHERS AN
FOR MARTIN SCORSESE BLUES. THEN I M
GENE (DADDY G) BARGE, IN 2018 WE
IN THE ORIGINAL 2120 CHESS STUDIO.
'HERE COMES THE JUDGE' WITH LEE FA
JUST BLAZE CO PRODUCING...

WITH MYSELF DOING
PIGMEAT MARKHAMS
VOCALS. GENE BARGE
PRODUCED WHAT CAN BE
CONSIDERED THE FIRST RAP
RECORD IN 1968...

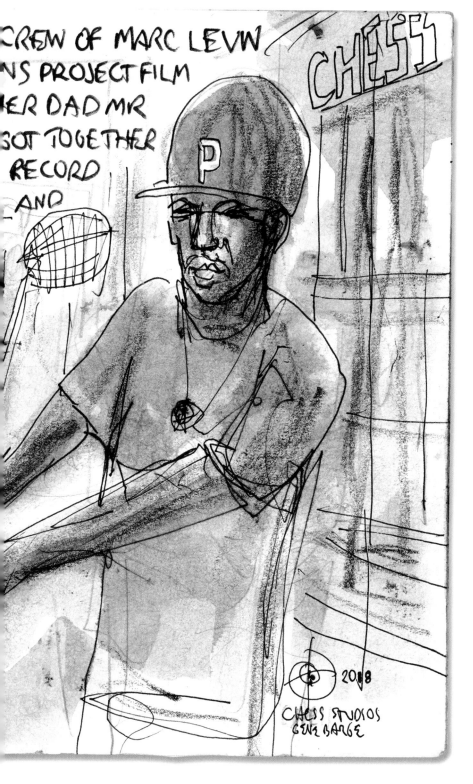

CREW OF MARC LEVW
NS PROJECT FILM
IER DAD MR
SOT TOGETHER
RECORD
AND

CHESS

2018

CHESS STUDIOS
GENE BARGE

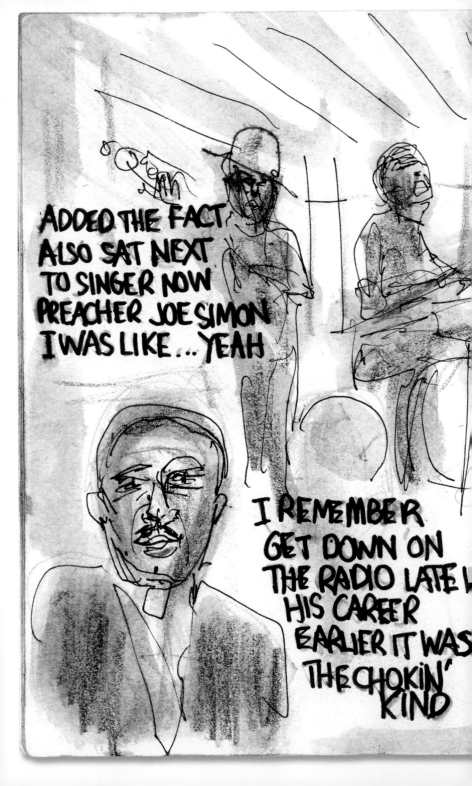

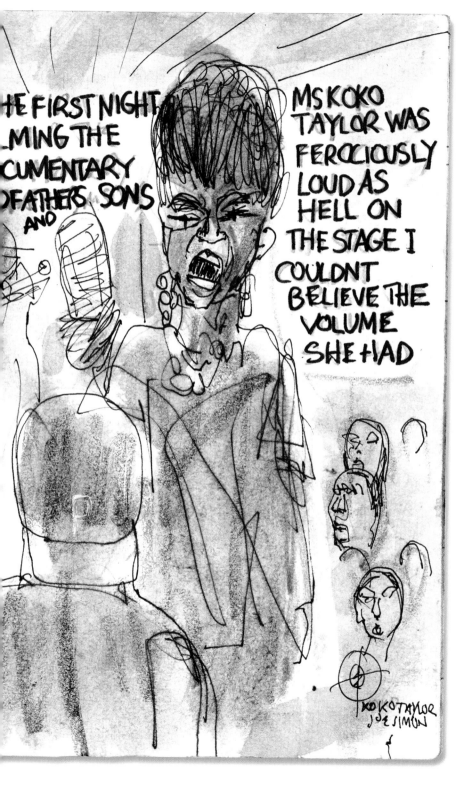

HE FIRST NIGHT
MING THE
CUMENTARY
OFATHERS SONS
AND

MS KOKO
TAYLOR WAS
FEROCIOUSLY
LOUD AS
HELL ON
THE STAGE I
COULDNT
BELIEVE THE
VOLUME
SHE HAD

KOKO TAYLOR
JOE SIMON

I WAS TAKING A FLIGHT BETWEEN
AND A WOMAN SAW THAT I WAS A
YOUNG DAUGHTERS ON THE TRIP.
 VOMIT BAGS AND ALL
SHE SAID SHE WAS THERE
IF I NEEDED SOME
HELP, I WAS LIKE
NAHH A BIT IRRITATED
THE WOMAN WAS MS
BETTY WRIGHT I WAS
LIKE, DAMN
MS WRIGHT
 MY
 BAD

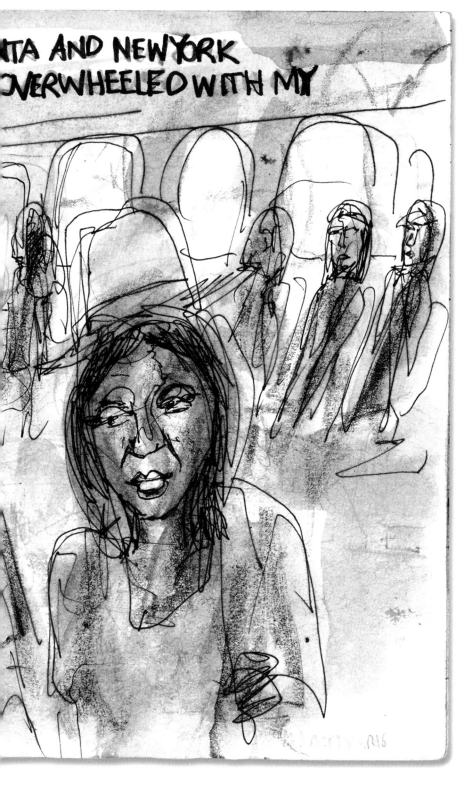

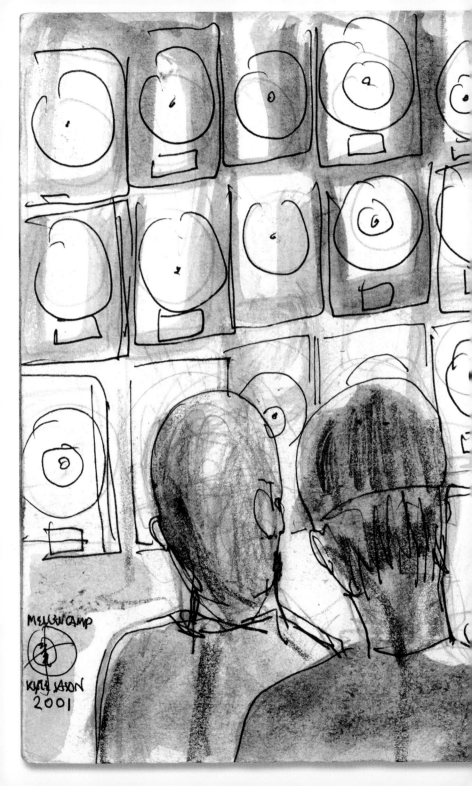

MELLENCAMP
KYLE BAXON
2001

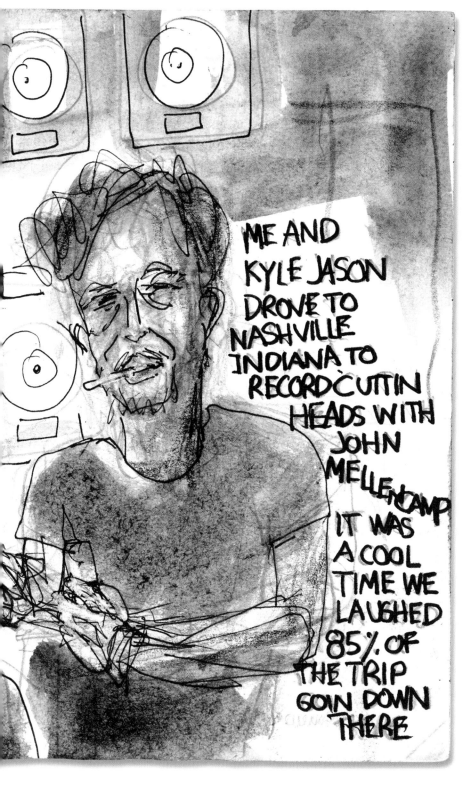

ME AND KYLE JASON DROVE TO NASHVILLE INDIANA TO RECORD CUTTIN HEADS WITH JOHN MELLENCAMP IT WAS A COOL TIME WE LAUGHED 85% OF THE TRIP GOIN DOWN THERE

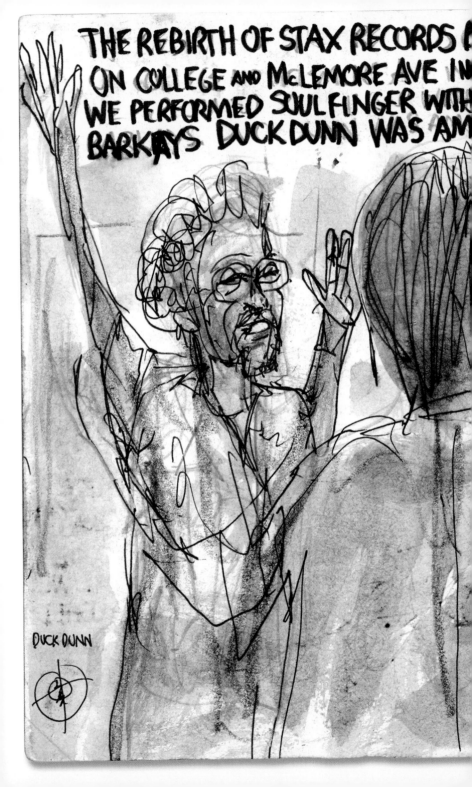

THE REBIRTH OF STAX RECORDS
ON COLLEGE AND McLEMORE AVE IN
WE PERFORMED SOUL FINGER WITH
BARKAYS DUCK DUNN WAS AM

DUCK DUNN

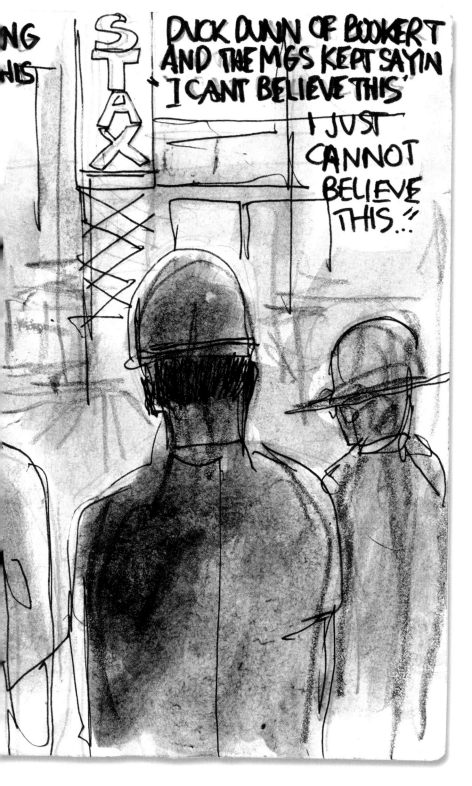

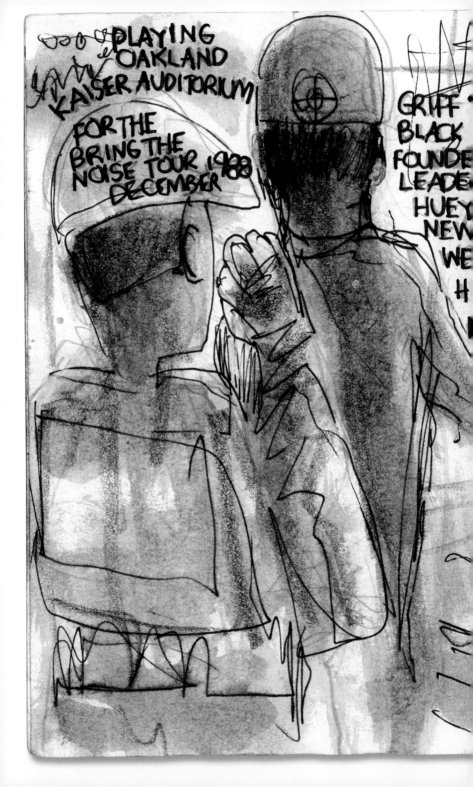

PLAYING
OAKLAND
KAISER AUDITORIUM
FOR THE
BRING THE
NOISE TOUR 1988
DECEMBER

GRIFF
BLACK
FOUNDE
LEADE
HUEY
NEW
WE
H

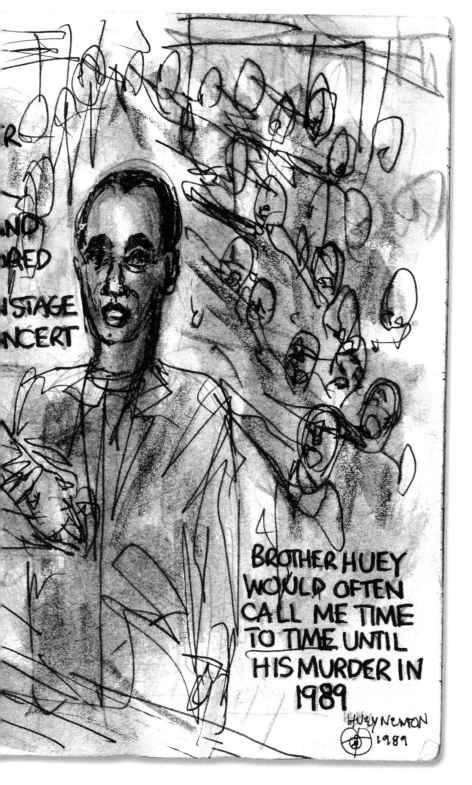

BROTHER HUEY
WOULD OFTEN
CALL ME TIME
TO TIME UNTIL
HIS MURDER IN
1989

HUEY NEWTON
1989

VISITING SEATTLE AT A MEETING
INVITED TO SEE A GAME AT NEW SA
SUPERSTARS I EVER MET WAS KEN GRI
DOMINIQUE WILKINS, BUT ABOUT KG
OWNER AND TECH PIONEER ROB GLAS
THE GAME KEN GRIFFEY
INVITES ME INTO THE
LOCKER ROOM AND I
MEET ALL OF
THE PLAYERS
AND THEY
WERE

ALL NICE
AND CORDIAL
ALTHOUGH MANY OF
THEM I THINK HAD
LITTLE CLUE OF WHO I WAS
KEN GRIFFEY JR TREATED ME
LIKE HIS BEST PAL. HIS LONGTIME
TEAMMATE HAROLD REYNOLDS I ME
LATER AND IS ALSO A FANTASTIC

THE OWNER OF THE MARINERS I WAS
STADIUM. ONE OF THE MOST HUMBLE
JR. THE OTHER IS BASKETBALLS MR
AS A FRIENDSHIP WITH MARINERS
WHO INVITED ME. AFTER

... PERSON WHO I'VE
HAD THE PLEASURE
OF BEING INTERVIEWED
BY AND WORKING
WITH. ONE TIME
AT MLB HE
CALLED UP
KGJ AND I
TOLD HIM
AGAIN
THANK YOU
FOR THAT
GREAT TIME
IN SEATOWN

KEN GRIFFEY JR
1999

SOUTH AFRICA WAS TWICE A MIND BLO
EXPERIENCE FOR ME VISITING JOHANNE
CAPETOWN 2009 AND 2010 PLAYI

2010 THE PROMOTER HU
INTRODUCED ME TO... M

PUBLIC ENEMY WAS
ALSO INVITED TO HIS
STAGE PLAY. DURING
ONE OF MANY VISITS
TO TOWNSHIPS I RAN
INTO 'UNC HUGHIE'
WHO PATTED ME ON
SHOULDER
AND CALLED
ME
'CHUCKIE'
BLEW MY
MIND
WITH
THAT

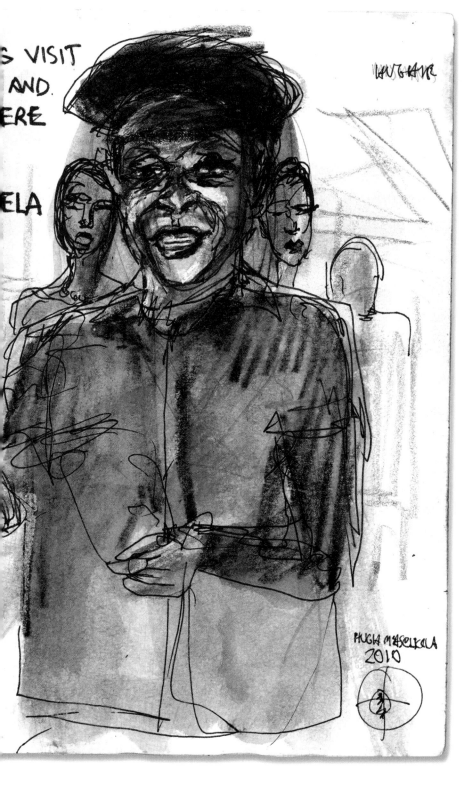

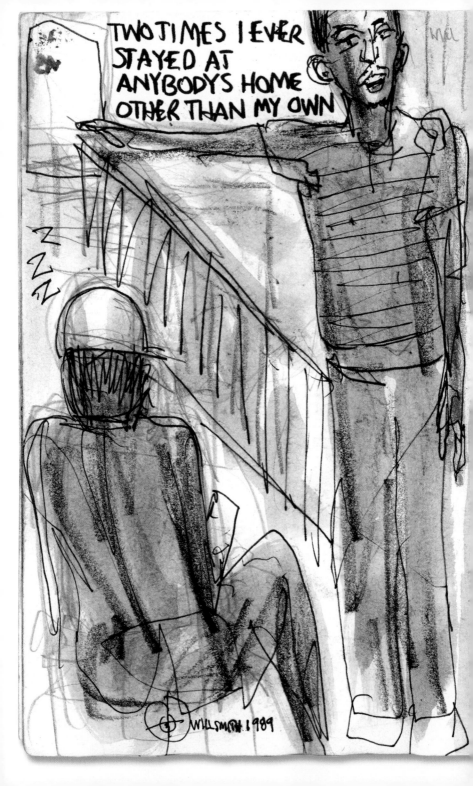

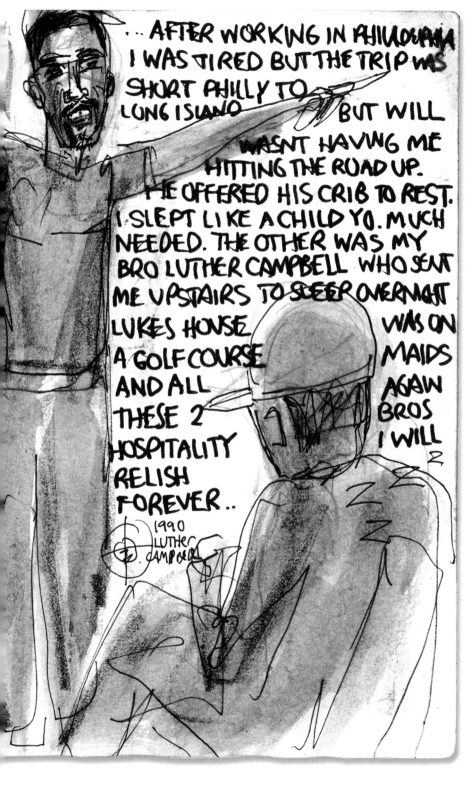

...AFTER WORKING IN PHILADELPHIA I WAS TIRED BUT THE TRIP WAS SHORT PHILLY TO LONG ISLAND BUT WILL WASN'T HAVING ME HITTING THE ROAD UP. HE OFFERED HIS CRIB TO REST. I SLEPT LIKE A CHILD YO. MUCH NEEDED. THE OTHER WAS MY BRO LUTHER CAMPBELL WHO SENT ME UPSTAIRS TO SLEEP OVERNIGHT

LUKES HOUSE WAS ON A GOLF COURSE MAIDS AND ALL AGAIN THESE 2 BROS HOSPITALITY I WILL RELISH FOREVER..

1990 LUTHER CAMPBELL

PROFESSOR GRIFF
DEFWITELY ALWAYS
HAD A RIGHT EYE FOR
TALENT.. HE SAW MANY
OF THE PERSONNEL TO
COME ON BOARD
PE WISE ALSO
IN FINDING TALENT.

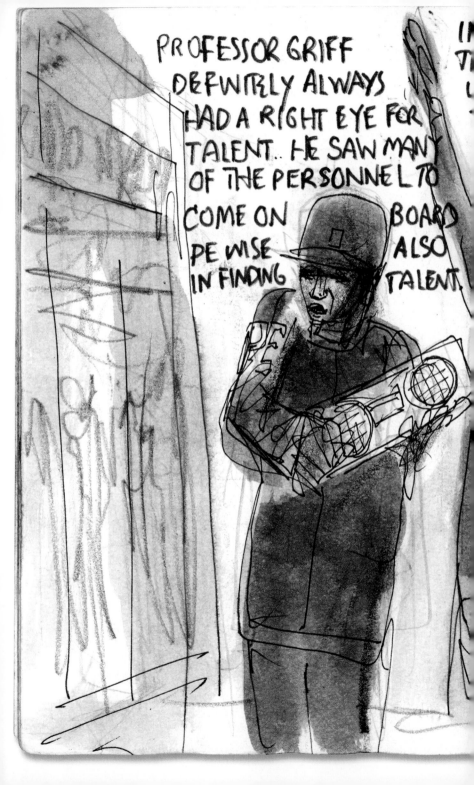

7 UPON OUR FIRST EMBARKMENT ON
ON DEF JAM INTERNATIONAL TOUR WITH
OL J. AND ERIC B AND RAKIM. PG DISCOVERED
ROUPS FEMALE RAPPERS THE SHE ROCKERS
NDING A YOUNG BETTY BOO AND MONIE
LOVE... GRIFF BEATBOXED TO
TO THEIR
RHYMES ON
MY BOX
OUTSIDE A
LONDON
McDONALDS)

1987
GRIFF BETTY BOO
SHE ROCKERS

I NEVER PUBLICLY ENDORSED A
WAS A SERIOUS CROSSROAD TO DO
SEEMS LIKE OUT OF SIGHT OUT OF M
WERE EVER IN OFFICE
WELL I COULDNT SEE
BYEDOM AT HIS AGE
SO I WENT BERNIE
SANDERS BECAUSE
OF HIS GREEN PARTY
BACKGROUND ...INVITED
ROSA
CLEMENTE
WHO RAN VP IN
2008 WITH
CYNTHIA
McKINNEY
FOR PREZ OUT OF
GEORGIA. PEOPLE
FORGOT I DID NOT
CHILDCARE (GRANDDAUGHTER) HEATH CARE
TOPICS I WAS CONCERNED WITH .. BUT
OPTICS...

2020
SANDERS CLEMENTE SILVERMAN VANDYKE

SIDENTIAL CANDIDATE BUT 2020
METHING ESPECIALLY POST MR 45.
USA FOLK FORGOT THAT THE OBAMAS

PARENTS) CLIMATE (TRAVELS) WERE
HEAD CRITICS ONLY SAW VISUAL

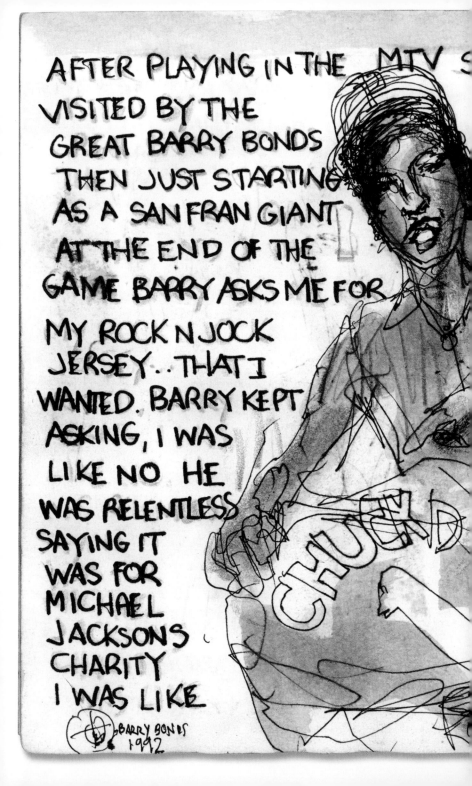

AFTER PLAYING IN THE MTV S
VISITED BY THE
GREAT BARRY BONDS
THEN JUST STARTING
AS A SAN FRAN GIANT
AT THE END OF THE
GAME BARRY ASKS ME FOR
MY ROCK N JOCK
JERSEY.. THAT I
WANTED. BARRY KEPT
ASKING, I WAS
LIKE NO HE
WAS RELENTLESS
SAYING IT
WAS FOR
MICHAEL
JACKSONS
CHARITY
I WAS LIKE

BARRY BONDS
1992

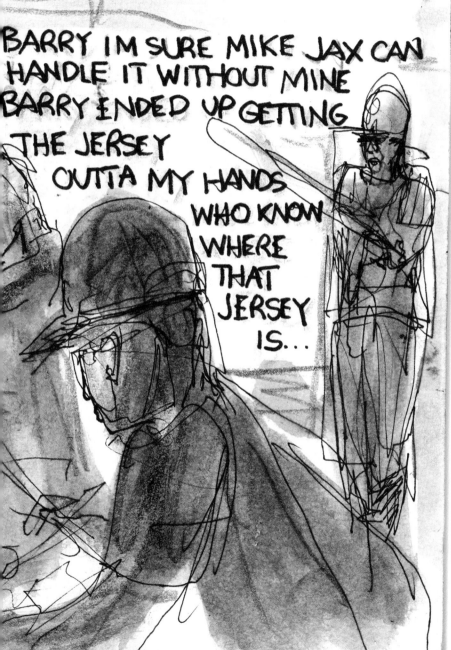

WHILE PERFORMING
ON STAGE IN NYC
IN 2002 GODFATHER
KURTIS BLOW VISITS
ME BACKSTAGE. HE
GIVES ME A TIP ON
HOW TO PROPERLY HOLD
A MIC. I GLADLY ACCEPTED
BUT ADDED I ONLY CUPPED
IT TO PROTECT MY TEETH
WHICH ONCE GOT
CHIPPED IN
CLEVELAND
WHEN ICE
CUBE BACKED
UP INTO ME
PLAYING ON
HIS TOUR

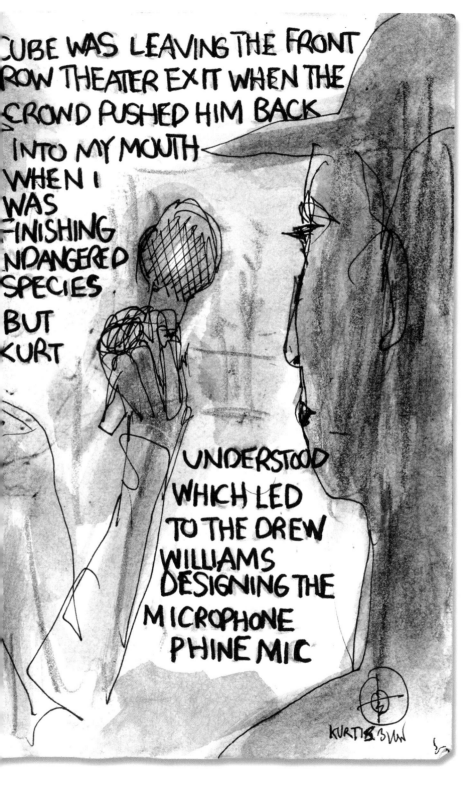

KOOL MOE DEE, SPECIAL K AND LA
RAP HEROES FOREVER. YEARS AGO
FOR A PROMOTION AFTER A LON
SIDE OF LIMO .. BUT NOBODY WA.
THEN I HEARD ONE OF
THEM SAY
"WTF ARE
WE .. AN
EXHIBIT?"
IT WAS
HILARIOUS
COCKY AND
WITTY ALL
AT THE SAME
TIME ...

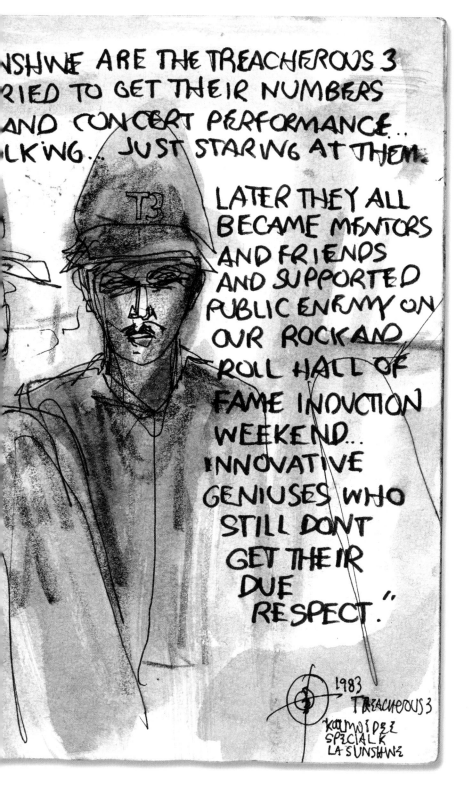

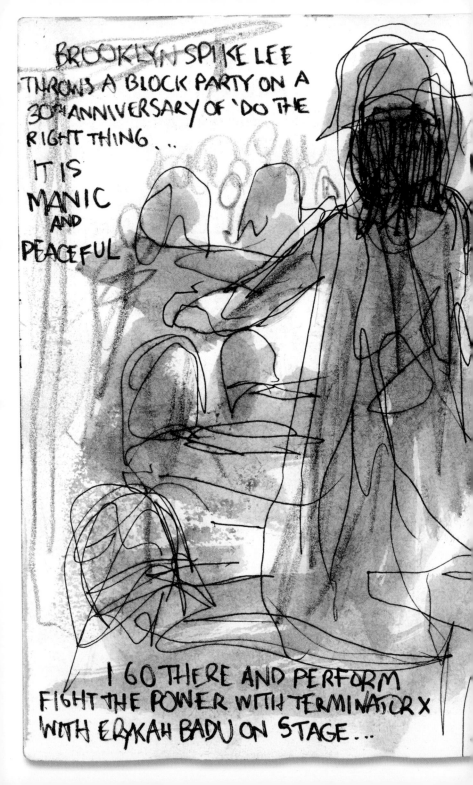

BROOKLYN SPIKE LEE
THROWS A BLOCK PARTY ON A
30TH ANNIVERSARY OF 'DO THE
RIGHT THING...
IT IS
MANIC
AND
PEACEFUL

I GO THERE AND PERFORM
FIGHT THE POWER WITH TERMINATOR X
WITH ERYKAH BADU ON STAGE...

SPIKE
ERYKAH 2019
TERMINATOR X

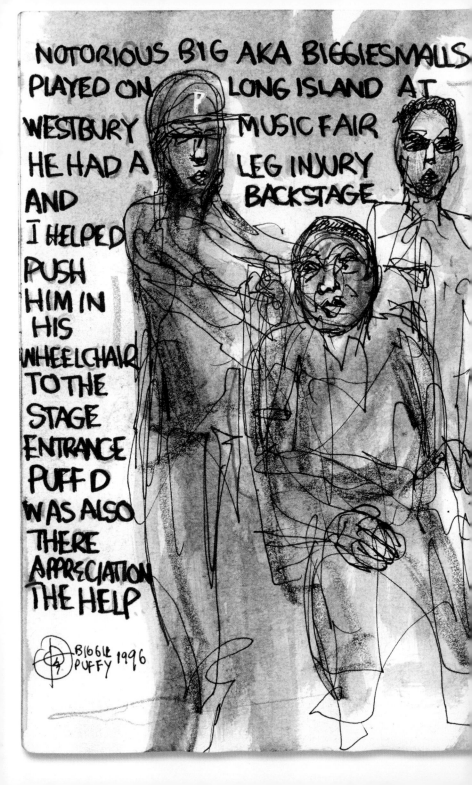

NOTORIOUS BIG AKA BIGGIE SMALLS
PLAYED ON LONG ISLAND AT
WESTBURY MUSIC FAIR
HE HAD A LEG INJURY
AND BACKSTAGE
I HELPED
PUSH
HIM IN
HIS
WHEELCHAIR
TO THE
STAGE
ENTRANCE
PUFF D
WAS ALSO
THERE
APPRECIATION
THE HELP

BIGGIE 1996
PUFFY

I HAD A LONG DEEP CONVO ON FLIGHT FROM NIGERIA WITH RICK ROZAY.. HE WAS CONGENIAL AND FROM HERE WE TAYE'D IN ONTACT

HE HAS EVEN ASKED ADVICE ON SOME THINGS

RICK ROSS 2010

THIS BROTHER IS A REAL CAT
THEY CAN SAY WHAT THEY
SAY ABOUT DAMON DASH
AT SUMMER JAM I RAN INTO HIM
BACKSTAGE AND I ASKED CAN I
INTERVIEW HIM
FOR MY AIR
AMERICA
UNFILTERED
WITH LIZZ
WINSTEAD AND
RACHEL MADDOW
I TOLD HIM
IT WOULD BE
EARLY
9 AM

ON A

AI
AMER

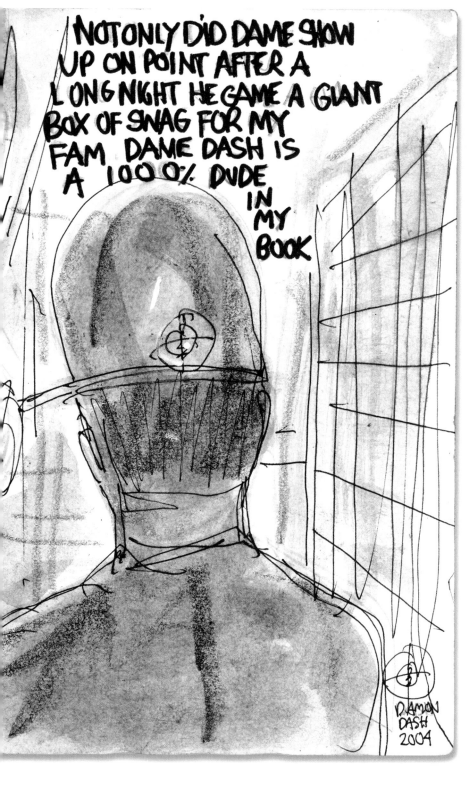

THE FIRST TIME I EVER TOOK A
PRIVATE JET WAS IN 1988. WE
PLAYED A MIAMI STADIUM
CONCERT. PROMOTED BY
LUTHER CAMPBELL OF 2 LIVE CREW
THE JET WAS ALSO OWNED
BY LUKE. IT FLEW US TO
THE AWAITING CONCERT
IN ATLANTA. THE OMNI

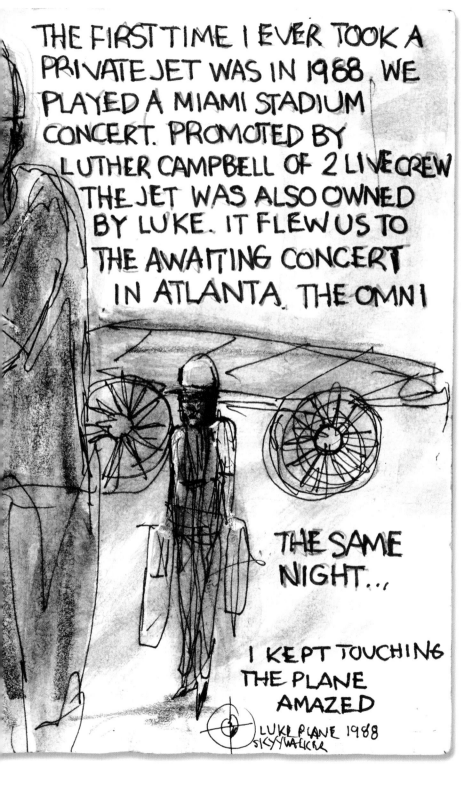

THE SAME
NIGHT...

I KEPT TOUCHING
THE PLANE
AMAZED

LUKE PLANE 1988
SKYYWALKER

AT A EVENT
I WAS JUST
WALKING
AROUND AND
LO AND
BEHOLD I RUN
INTO A YOUNG
KANYE WEST
WE SAY A
QUICK
WHATS UP
AND
HELLO AND
MOVE ON
OUR
WAYS

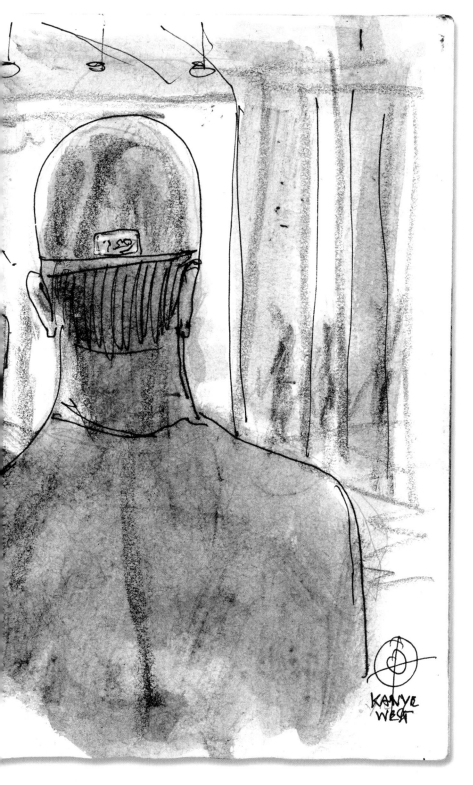

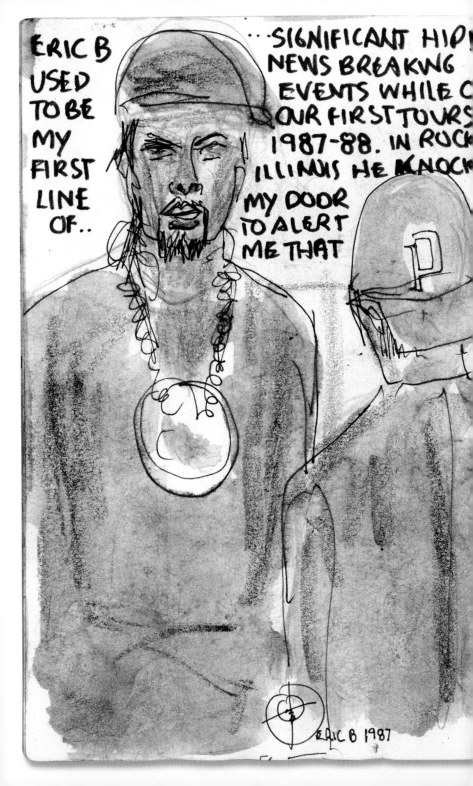

ERIC B USED TO BE MY FIRST LINE OF...

...SIGNIFICANT HIP NEWS BREAKING EVENTS WHILE O OUR FIRST TOURS 1987-88. IN ROCK ILLINOIS HE KNOCK MY DOOR TO ALERT ME THAT

ERIC B 1987

DJ SCOTT LAROCK HAD BEEN SHOT
AND MURDERED.. WE WERE
JUST
ABOUT REPLACED BY
TO BDP ON TOUR.
BE
... LATER THAT
 WINTER IN
 NASHVILLE
 WE DID A SHOW
 TOGETHAR
 AND HE
 KNOCKS
 ON MY
 DOOR
 TURNS
 ON THE TV
 CNN. THE NEWS
 SAID 2 GIRLS
 KILLED AT A
 PUBLIC ENEMY CONCERT
 WE HAD ALREADY BEEN
 AT THE HOTEL, DAYS INN
 DOWN THE BLOCK AND SLEEP.
 IT WAS A AFTER PARTY THAT HAD
 A STAMPEDE. STILL PE WAS BANNED
 3 YEARS FROM NASHVILLE.. AND WE
 DIDNT EVEN HEADLINE...

GRIPS REALITY MOMENT FOR A SO
SON COMING UP THE CELEBRITY ELEVATOR
EN ANOTHER KNOWN CELEBRITY SAYS OR
IR NAME. IT CAME FOR ME IN 1988
USIC PANEL IN N.Y. I DO REMEMBER
WITH CARLA THOMAS SONNY SHARROCK
ATTI LABELLE AND OTHERS. I EVEN
FORGOT WHAT IT WAS ABOUT
AND WHAT I SAID TO HAVE
MS PATTI SAY "I AGREE WITH
WHAT CHUCK
SAID". I WAS
LIKE STUNNED
FROZEN LIKE...
"PATTI LABELLE
SAID MY NAME"
LIKE I WAS
NOW
SOMEBODY!

PATTI LABELLE
1988

THE FIRST
CELEBRITY I
MET AFTER
ENTERING
STAROUMB AS
PE AND THE
FIRST TO GIVE
ADVICE.. WAS
THE ONE AND
ONLY RICK JAMES

OUR FIRST TOUR
1987 LICENSED TO
ILL WITH THE
BEASTIE BOYS
AND MURPHYS
LAW. OUR
STOP DRIVING
THAT 6
PASSENGER
VAN TO
BUFFALO
SUNY
ARENA...
RICK CAME
TO SHOW...

GU
W
INC
T

RICK JAMES
1987

G WHAT THIS WHOLE BEASTIE BOY HYPE
ALL ABOUT.. AFTER OUR SET HE AND THE
STONE CITY BAND CAME BACKSTAGE
DRESSING ROOM. RICK AND
ENTIRE BAND GREETED US...

.. AND THEN RICK GAVE US HIS
TWO WORDS OF ADVICE...
'STAY SAFE'.. AND RICK JAMES
AND THE STONE CITY BAND
EXITED OUT THROUGH THE
WINTERY DOORS INTO THE BLACK..

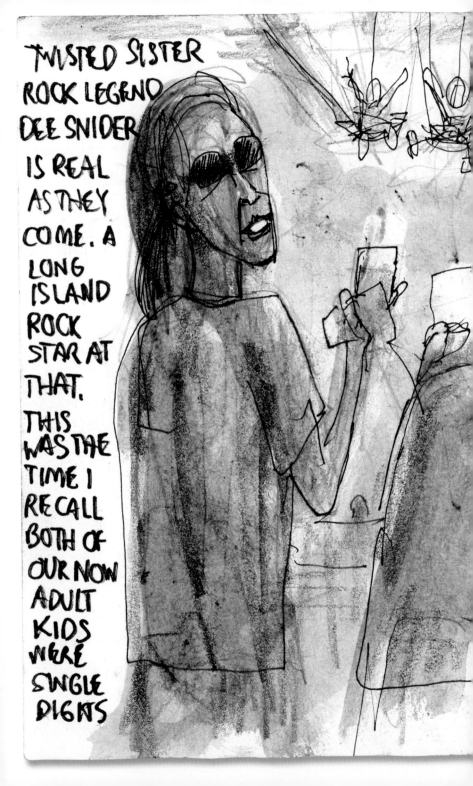

TWISTED SISTER
ROCK LEGEND
DEE SNIDER
IS REAL
AS THEY
COME. A
LONG
ISLAND
ROCK
STAR AT
THAT.
THIS
WAS THE
TIME I
RECALL
BOTH OF
OUR NOW
ADULT
KIDS
WERE
SINGLE
DIGITS

GROWING UP IN ROOSEVELT
AND ED JOHNSON. HANK WAS A YEAR O
NEIL AND ED COULD SING AND WERE E

MY GROUPS AND SING
WERE THE TURN A
COMMODORES ONCE
AND OJAYS.. AT M
THEY WERE OLD HITT
PLAY A SONG BAILE
ON THE
8 TRACK...

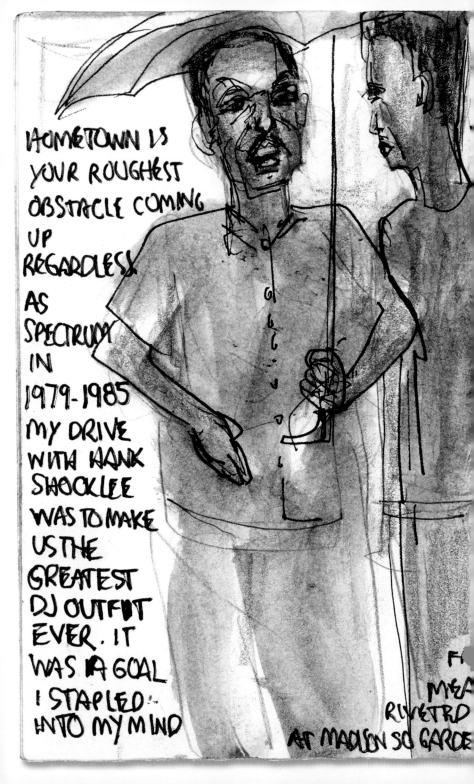

HOMETOWN IS
YOUR ROUGHEST
OBSTACLE COMING
UP
REGARDLESS.
AS
SPECTRUM
IN
1979-1985
MY DRIVE
WITH HANK
SHOCKLEE
WAS TO MAKE
US THE
GREATEST
DJ OUTFIT
EVER. IT
WAS A GOAL
I STAPLED
INTO MY MIND

FI
MEA
RIVETRD
AT MADISON SQ GARDE

WARREN OWNED THE ROOSEVELT ROLLER
K WHICH SERVED OUR AREA SO WELL.
AVE A DEPLETED AREA HOPE
THE JOY OF MUSIC AND
 RECREATION. MR
 WARREN WAS A GOOD
 MAN A TOWN HERO
 AND LOCAL MAGNATE
 OWNING THE RINK AND
 A CLUB

MR WARREN
1983

ONE TIME HANK ASKED MR
WARREN FOR A CHANCE TO PERFORM
AT A BIG RINK CONCERT COMING UP.
WE WERE STANDING IN A RAINY
PARKING LOT HANK AND MR WARREN
WAS UNDER A UMBRELLA, I WASNT, MR
WARREN SAID TO HANK NOT EVEN LOOKING
T ME AND SAID ' I LIKE YOU HANK BUT
Y I DONT THINK YOU GUYS CAN PULL!
TO DRAW THE PEOPLE. THIS STAYED
Y BRAIN FOR YEARS. WHEN I WAS ON STAGE
EARS LATER... IT WAS MOTIVATED... THANX

I WAS COMING OUT OF A MEETING ON
 PULLS UP AND STOPS ME FROM CROSS
SITTING IN IT. AT THE WHEEL W

WHO I WAS
INTRODUCED VIA DI
RED ALERT...
HE SAYS "CHUCK
 I WANT YOU TO
MEET MY MAN
THE NEXT
DEVESTATING
MC.. HIS
NAME IS
"PUNISHER!
I THEN SHOOK
HANDS WITH
THE ONE WE KNEW
 AS BIG PUN

OWAY NYC, AND A JEEP WRANGLER
HE STREET, 2 BURLY PUERTO RICANS
YOUNG FAT
JOE

FAT JOE
BIG PUN

MYSELF AND HANK SHOCKLEE PROMOT
SIGNIFICANT GIGS AND CONCERTS ON
BECAUSE SITUATIONS NEVER WANTED
PROPERLY OR INCLUDE US BECAUSE WE

WE PROMOTED THE FIRST RAP
RECORDED STARS AS MUCH
AS WE COULD. QUITE A FEW
TRIPS TO HARLEM AND
ENJOY RECORDS
OWNED BY
BOBBY
ROBINSON
A
LEGEND
...

TO TH
GEE, WH
BACK TO HA
HE COULDN
A FEW WEEK
AND BOBBY IN TH

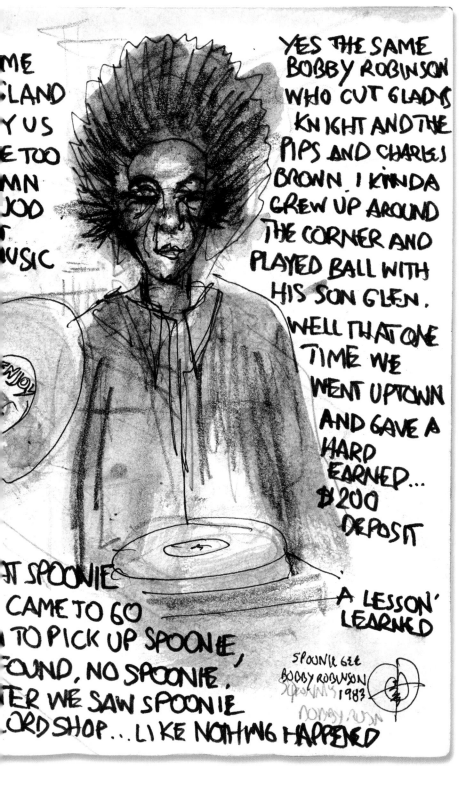

JAMMASTER JASON MIZELL, I REM[EMBER]
GAVE THAT FIRST INTERVIEW TO RU[N]
BECAME A MAIN FIXTURE IN THE QUE[EN]

HIS STYLE WAS SO
EVIDENT FROM THE
JUMP. IT WAS JAMAICA
AVE ALL THE WAY.
JMJ MADE IT A HABIT
TO KEEP COMING TO
WBAU RADIO FROM
HOLLIS JUST 15
MINUTES AWAY.

HE WAS TH[E]
WHEN I T[?]
ANDRE DO[?]
BROWN [?]
ENEMY N[?]

.. DRES OPERATING ROOM
RADIO SHOW END OF 1984. EARLIE[R]
I SAW JMJ AT WBAU AND PEEPED THEY [?]
THE 1ST FRESH FEST AT THE SPECTRUM IN P[?]
I ASKED JAY IF I COULD COME DOWN, JAY[?]
SO I DROVE DOWN THERE AND WAS AT TH[E]
AND ASKED FOR JAY, I DOUBTED IT BECA[USE]
VERY HECTIC BACK THERE... THEN...

ER THE FIRST DAY MR BILL STEPHNEY
IC IN 1983. EVENTUALLY JAY
TO LI HIP HOP CONNECTION,

D
DRE
BUC
ER ONE
O TAPE..
NG...

JAMMASTER
JAY
1984

A HATTED FIGURE WALKED
UP THE RAMP, IT WAS JAY
WITH 2 TICKETS. AMAZING.
SUCH A MAN OF HIS WORD.
AND HONOR, LATER JAY INVITED
US TO THE MSG CONCERT WHERE
SUMMER THE CROWD HELD UP ADIDAS
PLAYING IN 86. HEAD NODDING THAT
ELPHIA DEF JAM WAS THE PLACE FOR
'I GOT YOU' PUBLIC ENEMY. JMJ WAS OUR
KING AREA UNION LEADER. I MISS THIS
T WAS DUDE AND HIS INTEGRITY

IN LIFE WE MEET EVERY SINGLE P...
NOT KNOW EXACTLY WHY, IN ESS...
ARE HERE FOR A BLINK THUS WE...
RELISH EVERY
MOMENT WE
HAVE, THE GODS
MAKE IT THE
PRESENT. ONCE
UPON A TIME
A INTERVIEW
SPUN INTO A

LIFET...
JOUR...
LIVIN...
LOVE...
AND...
COMP...
OF ITS A...
CHALLEN...
AS LIFE...
GOES...
FA...
T...
U...
B...
P...
LI...
T...

N FOR A REASON AND ITS OK TO

WE

LD

OF
E
PECT
IE
TES,
IDE

OS
L AS
TIMATE
... MAN
AS
RITES
MAINING
F ..

THUS THE
APPRECIATION
FOR THAT
EVENT IS
ANSWERED TO

DR G T J
IN GRACE
AND GRATITUDE.

A LIFE
STATEMENT
IN LOVE AND
PEACE...
IT WAS,
A GOOD
DAY..

DR GAYLE JOHNSON
2007

JAMES ALEXANDER FOR MANY YEAR
START I WOULD SEE WORKING AS A
PROMOTIONAL MAN FOR DE
WHICH STARTED OUT AS A
LABEL DISTRIBUTED BY
CBS AND THEN IT WAS
PURCHASED BY SONY IN
1988. I WAS ALWAYS LIKE
'I KNOW YOU FROM SOMEWHERE'
IT WAS EASY THAT SAME
JAMES HAD BEEN A
LEGEND FOREVER
FOUNDER OF THE
BAR-KAYS, HE
WAS THE ONE WHO
DIDNT FLY ON
THAT PLANE THAT
OTIS REDDING AND
HIS BAND PERISHED ON.
IT ALL CAME TOGETHER
AND MADE TOO MUCH SENSE

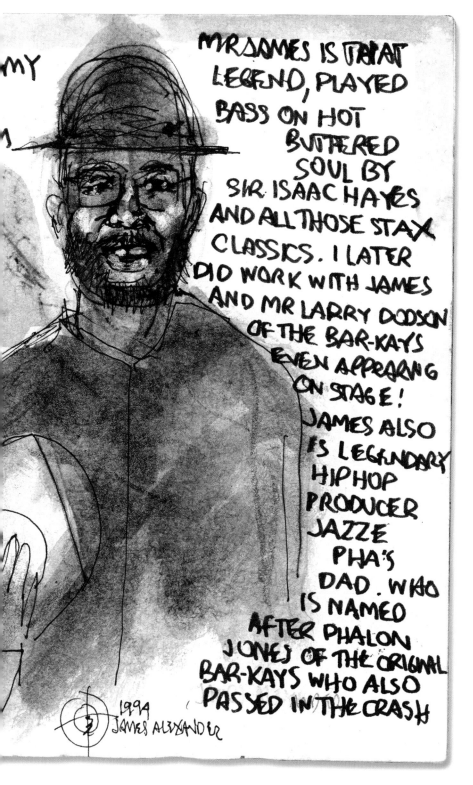

MY

M

MR JAMES IS THAT
LEGEND, PLAYED
BASS ON HOT
BUTTERED
SOUL BY
SIR ISAAC HAYES
AND ALL THOSE STAX
CLASSICS. I LATER
DID WORK WITH JAMES
AND MR LARRY DODSON
OF THE BAR-KAYS
EVEN APPEARING
ON STAGE!
JAMES ALSO
IS LEGENDARY
HIPHOP
PRODUCER
JAZZE
PHA'S
DAD. WHO
IS NAMED
AFTER PHALON
JONES OF THE ORIGINAL
BAR-KAYS WHO ALSO
PASSED IN THE CRASH

1994
JAMES ALEXANDER

HEAVY D TO ME WAS A
HIP HOP SAINT OF A DUDE
ALWAYS SMILE LIT. HIS
SPIRIT LIKE DOUG E
FRESH INFUSED A
GREAT DEAL OF JOY IN
HIP HOP. WE EMRRGED
AROUND THE
SAME TIME
AND
TOURED
TOGETHER
IN
1990

..WE CO
MEMBE
LOADING
IN

WED UNTIL THE TRAGIC FALL OF DANCER
JUBLE T ROY OF THE BOYZ OFF A BACK
K AT MARKET SQUARE ARENA IN
OLLS,.. TROY LOST HIS LIFE. THE
TOUR TRIED TO GO ON
BUT THIS WRECKED
HEV. EVERY SHOW
WAS A ORDEAL,
FINALLY HE TOLD
ME ONE TO ONE
HE COULDNT
DO IT
ANYMORE

IN THE BACKSTAND)
OF THE SUPERDOME W
NEW ORLEANS, I
TOTALLY OVERSTOOD
THE PROMOTRR) AND
HIS RECORD LABEL AND
MANAGEMENT DIO NOT.
I TOLD HEV TO GO HOME
WE WOULD HANDLE THE
REST OF THE TOUR
AND DID... HEAVYn

JVY D
10

AHMET ERTEGUN IS THE KIN
HAD THE ONE OCCASION TO
RHYTHM AND BLUES FOUNDAT
YEARLY EVENT
USED TO GIVE
OUT
SUPPLEMENT
CHECKS TO
OG ARTISTS
A OLDER
QUITE TINY
FRAIL ARTIST
NAMED...

F ATLANTIC RECORD AND I
RTICIPATE IN A EVENT. THE
... FAYE ADAMS
WAS A KEY
R & B RECORDNG
ATLANTIC ACT
EARLY 1950s
WE CALLED HER
TO THE STAGE
MR ERTEGUN
AND I
PRESENTED
HER WITH
A CHECK
BUT I
DIDNT
SEE THE
AMOUNT
...

FAYE ADAMS
AHMET
ERTEGUN
1998

THAT TIME I PERFORMED WITH AWARD AND AFTERWARDS TALK BACKSTAGE AND AS I COMPLIMENT HIM HE TELLS ME THAT HE JUST GOT THE TASK OF ACTING 'RAY CHARLES' IN A BIOPIC. I LOOK AT JAMIE WITH MY ART EYE AND I SAY ...

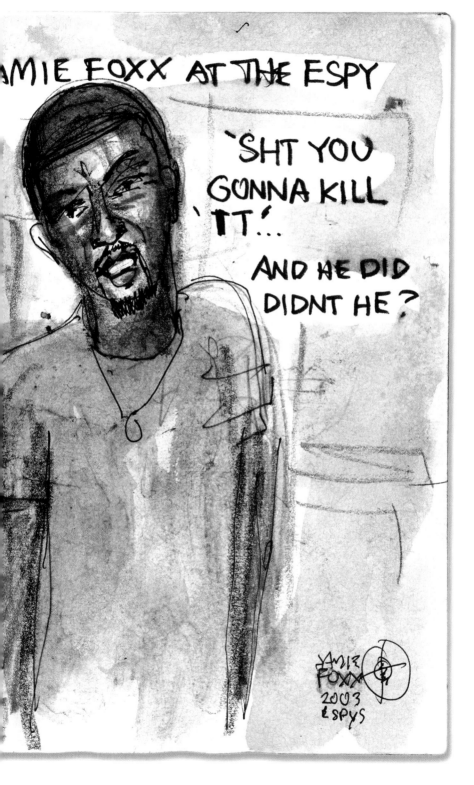

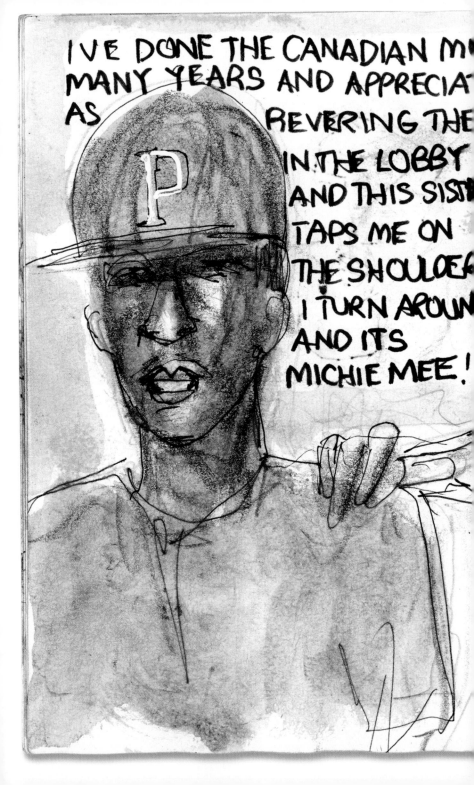

IVE DONE THE CANADIAN M?
MANY YEARS AND APPRECIAT?
AS REVERING THE
 IN THE LOBBY
 AND THIS SIST?
 TAPS ME ON
 THE SHOULDE?
 I TURN AROUN?
 AND ITS
 MICHIE MEE!

FESTIVAL AND CONFERENCE
THE RESPECT UP TOP AS WELL
ARTISTRY. I'M WALKNG

..THE QUEEN OF CANADIAN
HIP HOP. SHE JUST GOT
HER INDEPENDENCE AND
I INTRODUCED HER TO THE
NEW MP3 ONLY ATOMIC
POP LABEL IN 1999. A
PIONEER IN MANY WAYS

WE TOURED IN CANADA
PROMOTING HER
MUSIC. SILLY USA
CANADA BORDER BS
PREVENTED HER FROM SHOWS
IN THE USA THEN. ONE OF
THE BEST ON THE MIC.. GOVT
POLITICS SHOULD BE
ASHAMED

MICHIE MEE
1999

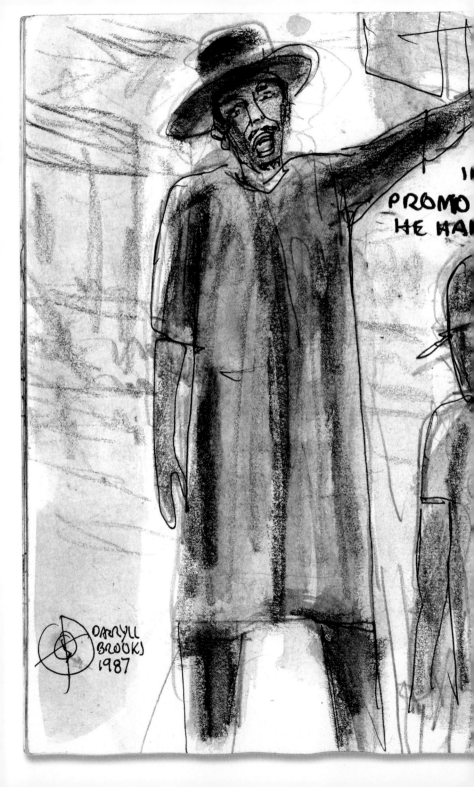

UPON FIRST TOURING IN 1987
[IMMEDI]ATELY I NOTICED STANDOUT FIGURES
[D]ARRYLL BROOKS WAS OUR FIRST ONE.
[A]N A GROUNDBREAKER WITH HIS
PARTNER CAROL KIRKENDALL AND HIS
COMPANY G-STREET EXPRESS OUTTA
WASHINGTON DC, THEY PROMOTED ALL
THE ARENA FUNK SHOWS, THE GOGO SHOWS
AND RAP ARENA CONCERTS IN THE 80'

I WAS INTRODUCED TO MR BROOKS
BACKSTAGE UPON PLAYING OLD
CAPITAL CENTRE IN LANDOVER,
ON THE BEASTIE BOYS LICENSED TO
ILL TOUR. DARRYLL ADVISED US
THAT WE NEVER LOOK AT THE
SCREENS WE WERE ABOUT TO
BY ON. IT KILLED NEW ACTS
PERFORMANCES HE SAID.
I ALWAYS FOLLOWED HIS ADVICE
MADE ME A BETTER BIG CROWD
PERFORMER. DARRYLL IS A LEGEND
GREAT HUMAN BIG BROTHER FIGURE

TO ME MINISTER
LOUIS FARRAKHAN
PULLED OFF THE
IMPOSSIBLE DREAM
IN THE UNITED
STATES OF AMERICA
WHEN HE LED THE
MILLION MAN MARCH
IN OCTOBER 1995
A MILLION PLUS
BLACK MEN ON THE
WASHINGTON DC MALL
HIS MOMENTUM OF
CONSCIOUSNESS IN THE
MOVEMENT AGAINST
THE COINTELPRO OF
THE 20TH CENTURY.
NECESSARY FOR THE
KNOWLEDGE OF SELF.
THE NATION OF ISLAM
WAS AS POLITICAL AS
SPIRITUAL AND GAVE
US CHOICES TO

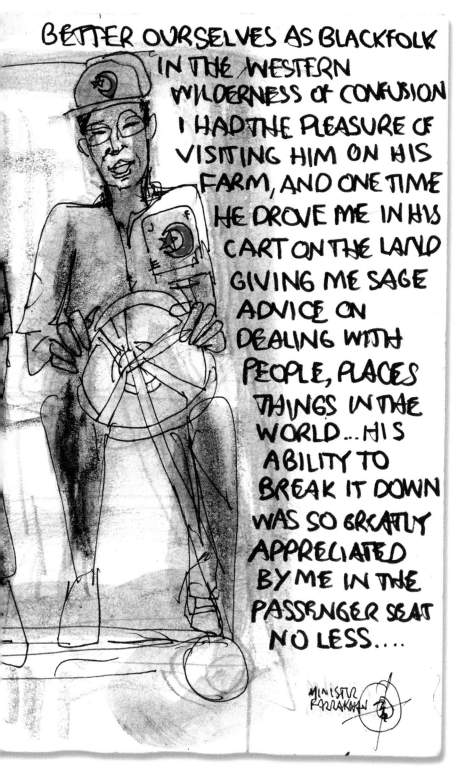

BETTER OURSELVES AS BLACKFOLK IN THE WESTERN WILDERNESS OF CONFUSION I HAD THE PLEASURE OF VISITING HIM ON HIS FARM, AND ONE TIME HE DROVE ME IN HIS CART ON THE LAND GIVING ME SAGE ADVICE ON DEALING WITH PEOPLE, PLACES THINGS IN THE WORLD ... HIS ABILITY TO BREAK IT DOWN WAS SO GREATLY APPRECIATED BY ME IN THE PASSENGER SEAT NO LESS....

MINISTER FARRAKHAN

SPIKE LEE HAS SORTA PUT
PUBLIC ENEMY ON THE MAJOR SOC
MAP WITH HIS FILMS. WE BOTH FOU
OUR RESPECTIVE GROOVES IN THE 198
BUT FILM IS SIGHT AND SOUND.. I GIV
SPIKE THE CREDIT OF REALLY MAKIN
FIGHT THE POWER
THE SONG THAT IT IS..
AFTER DO THE RIGHT
THING, SPIKE THEN
FILMED THE MOVIE
MALCOLM X FEATURING
DENZEL WASHINGTON.
SPIKE WANTED PE TO
DO THE THEME FOR IT..
THE MOVIE HAD SOME TENSION
BECAUSE SPIKE FELT HE DIONT NEEL
TO GET PERMISSION FROM THE NATIO
OF ISLAM TO SHOOT IT.. SO SPIKE AS
ME TO COME DOWN AND VIEW THE
PRE SCREENING TO SEE HOW I COULD
ADD THE SONG.. SO I INVITED

R KHALID ABDUL MUHAMMAD TO COME
EE IT WITH ME.. SPIKE MEETS US AT
THE DOOR BUT POLITELY TELLS KHALID
THAT HE CANT SEE THE FILM
KHALID ASKS WHY NOT?
SPIKE GIVES ANSWER AND
STANDS
FIRM.

SPIKE
KHALID
1992

IT WAS BACK AND FORTH THEN
I POLITELY BOW OUT AND
EAVE WITH KHALID WHO I CAN STILL SEE
HE SUN BEAMING SWEAT BEADS ON HIS
ALD HEAD. IT WAS 92 DEGREES ON 50th
NYC AND ITS A FACT I DIDNT WANNA
ET IN THE MIDDLE OF IT. I REFERRED
RRESTED DEVELOPMENT TO SPIKE AND
ATS HOW THEY GIDED UP DOING THE
NG REVOLUTION AS THE THEME.

IN THE 1960S GOING INTO THE 1970

BECAME KAREEM ABDUL-JABBAR A

ANGELA DAVIS WAS PUBLIC ENEMY

MOST WANTED BY THE FBI. THEY

UCLA IN COMMON AS A KID

ALSO
LEARNED
ABOUT
BUNCHY
CARTER
ON THAT
CAMPUS..
WE USED TO
YELL FREE AS LOUD AS
HUEY NEWTON, I VOTED
FOR ANGELA DAVIS FOR
USA PRESIDENT
IN 1980. 1979
MY FIRST YEAR
I WAS ABLE
TO VOTE FOR
A USA
PRESIDENT

I M
DA
A P
SAN
THE
LEE
LATE
WOR
W

LACK WAS BEAUTIFUL, LEW ALCINDOR

IS

IS
N AT
AT
UZ IN
AS A
R
SSISTED

AYE
ELPED
G
TO
GB
I HAD
HONOR
NTIONING
U HER BACKSTAGE
THE GREEN ROOM BEFORE TALK.

ANGELA
DAVIS

WE THE BOMB SQUAD WERE DO
WARNER BROTHERS OFFICES IN BUM
I FORGOT ABOUT WHAT EXACTLY TA
WAS SPECIFICALLY ABOUT BUT WHO I

IT WAS WARNER PREZ MO
WAS COOL THEN THE DOOR O
REVEALED STING, WHEN HE
MORE THAN 5 MINUTES LATE
KRAVITZ BRAND NEW AT TH
WALKED IN CRADLING HIS B
LENNY WAS JUST MARRIED T

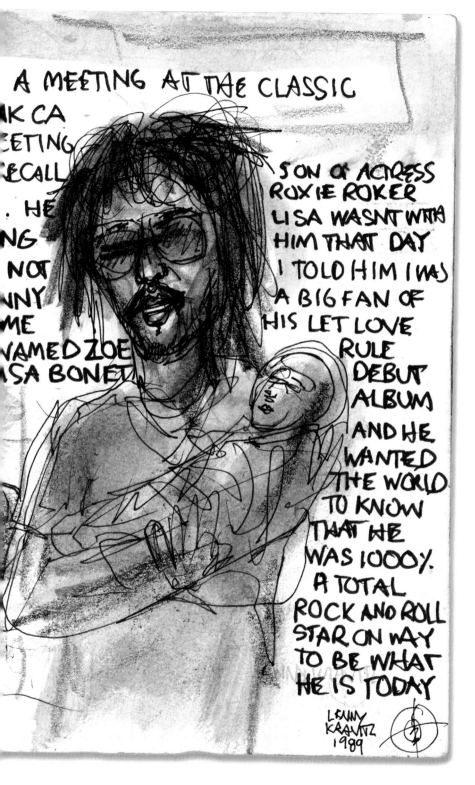

A MEETING AT THE CLASSIC

NK CA
EETING
ECALL
. HE
NG
NOT
NNY
ME
NAMED ZOE
ISA BONET

SON OF ACTRESS
ROXIE ROKER
LISA WASNT WITH
HIM THAT DAY
I TOLD HIM I WAS
A BIG FAN OF
HIS LET LOVE
RULE
DEBUT
ALBUM
AND HE
WANTED
THE WORLD
TO KNOW
THAT HE
WAS 1000%.
A TOTAL
ROCK AND ROLL
STAR ON WAY
TO BE WHAT
HE IS TODAY

LENNY
KRAVITZ
1989

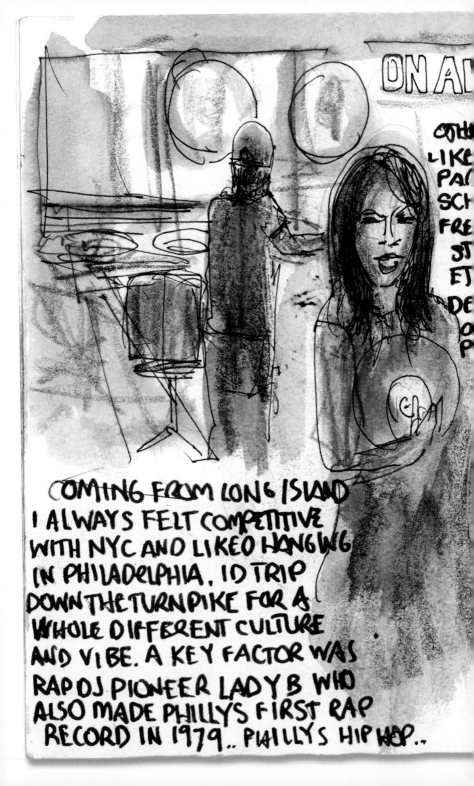

ON AI

OTH
LIKE
PA
SCH
FRE
ST
ET
DE
OP

COMING FROM LONG ISLAND
I ALWAYS FELT COMPETITIVE
WITH NYC AND LIKEO HANGING
IN PHILADELPHIA. ID TRIP
DOWN THE TURNPIKE FOR A
WHOLE DIFFERENT CULTURE
AND VIBE. A KEY FACTOR WAS
RAP DJ PIONEER LADY B WHO
ALSO MADE PHILLYS FIRST RAP
RECORD IN 1979.. PHILLYS HIP HOP..

WAS REALLY OPEN, THE DJS INNOVATED
LIKE CASH MONEY, CHEESE, JAZZY JEFF

:S

D
WCE
YB
L
-D
:99

OR BY EC LAROCK
OR MIMI ON
WDAS. ONE
TIME I RECALL
MCLYTE IN THE
BOOTH AT
POWER 99 PROMO.
LADY B TOOK THE
EXTRA EFFORT TO
BOOST AND SUPPORT
THE CAREERS OF
HIPHOP WOMEN MCS AND DJS. .

LADY B 1989
MCLYTE

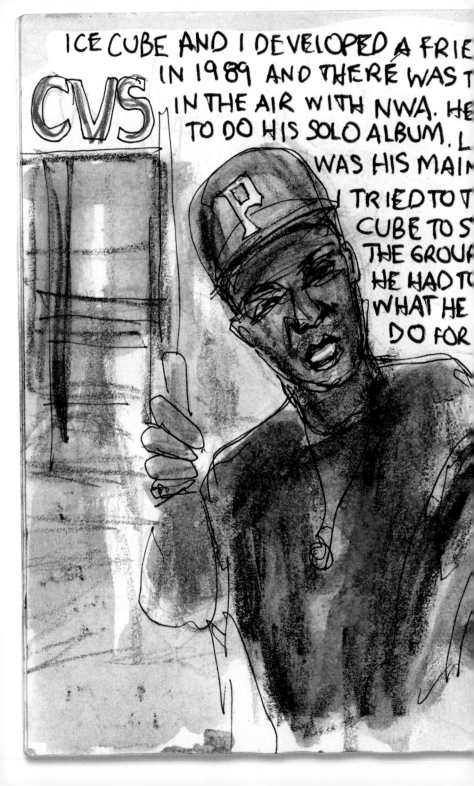

ICE CUBE AND I DEVELOPED A FRIE
IN 1989 AND THERE WAS T
IN THE AIR WITH NWA. HE
TO DO HIS SOLO ALBUM. L
WAS HIS MAIN
I TRIED TO T
CUBE TO S
THE GROUP
HE HAD TO
WHAT HE
DO FOR

CVS

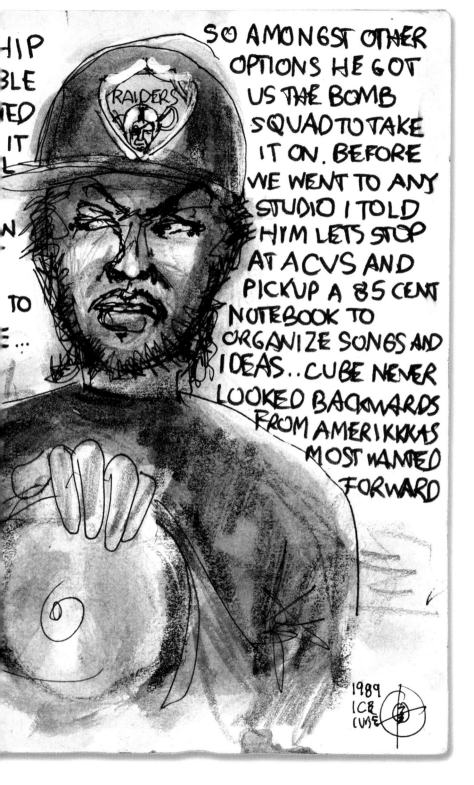

HIP
BLE
TED
IT
L

N

TO
E...

SO AMONGST OTHER
OPTIONS HE GOT
US THE BOMB
SQUAD TO TAKE
IT ON. BEFORE
WE WENT TO ANY
STUDIO I TOLD
HIM LETS STOP
AT A CVS AND
PICKUP A 85 CENT
NOTEBOOK TO
ORGANIZE SONGS AND
IDEAS.. CUBE NEVER
LOOKED BACKWARDS
FROM AMERIKKKAS
MOST WANTED
FORWARD

1989
ICE
CUBE

TECHNOLOGY ALWAYS CAUGHT MY FANCY
LEADING ME STRAIGHT INTO HIP HOP AND RA
THROUGHOUT THE YEARS. MY FRIEND MC J!
OF JJFAD GAVE ME A RIDE TO VISIT A
DR DRE
SESSION OF
FINISHING UP
THE DOC
NOBODY CAN DO
IT BETTER
ALBUM IN
TORRANCE
CALIF.

MC
198

INSIDE HER CAR WAS THE FIRST CAR
D PLAYER I EVER SAW. ESPECIALLY GOT ME
WHEN SHE PRESSED A BUTTON
AND GOT IMMEDIATE REWIND
THAT TOTALLY MADE
ME WANT TO
GET ONE
A.S.A.P.

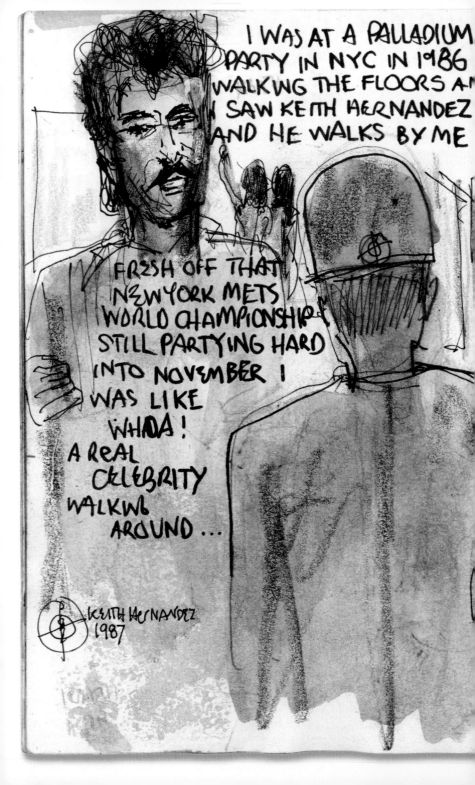

I WAS AT A PALLADIUM
PARTY IN NYC IN 1986
WALKING THE FLOORS AN
N SAW KEITH HERNANDEZ
AND HE WALKS BY ME

FRESH OFF THAT
NEW YORK METS
WORLD CHAMPIONSHIP
STILL PARTYING HARD
INTO NOVEMBER I
WAS LIKE
WHOA!
A REAL
CELEBRITY
WALKING
AROUND...

KEITH HERNANDEZ
1987

HAT SAME TIME WE WERE FINISHING UP
BECORDING THE FIRST PUBLIC ENEMY LP
YO! BUM RUSH THE SHOW AT A LOWER
NHATTAN CITY HALL AREA STUDIO NAMED
'I N S'. GOING TO GET
SOMETHING TO EAT I
SEE METS WORLD
CHAMP PITCHER RON
DARLING WITH A FLY
LADY..

I SAY
60
CHAMP
HE
SAID
THANKS

RON DARLING
1986

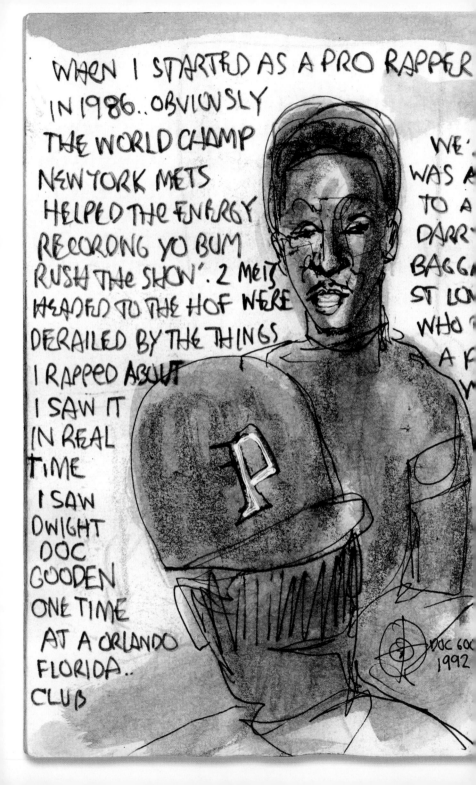

WHEN I STARTED AS A PRO RAPPER
IN 1986.. OBVIOUSLY
THE WORLD CHAMP
NEW YORK METS
HELPED THE ENERGY
RECORDING YO BUM
RUSH THE SHOW'. 2 METS
HEADED TO THE HOF WERE
DERAILED BY THE THINGS
I RAPPED ABOUT
I SAW IT
IN REAL
TIME
I SAW
DWIGHT
DOC
GOODEN
ONE TIME
AT A ORLANDO
FLORIDA..
CLUB

WE'
WAS A
TO A
DARR
BAGGA
ST LO
WHO
A F
W

DOC GOO
1992

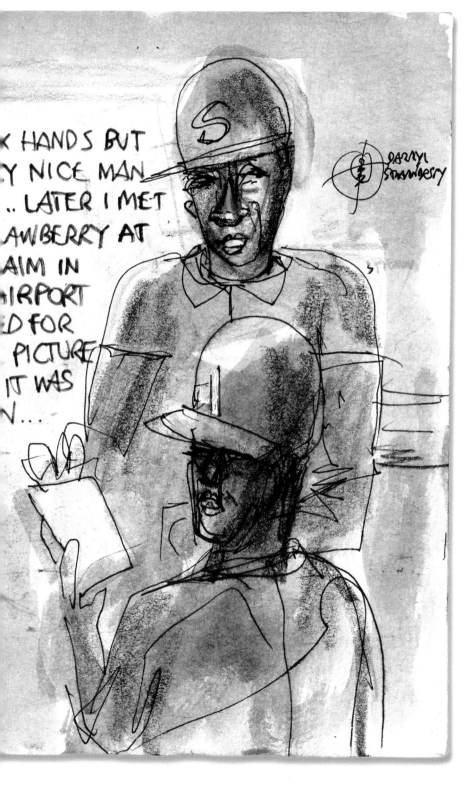

K HANDS BUT
Y NICE MAN
.. LATER I MET
AWBERRY AT
AIM IN
AIRPORT
D FOR
PICTURE
IT WAS
N...

DARRYL
STRAWBERRY

I WOULD ALLOW
A JOB TO TAKE
AND WORK MY
BODY BUT NEVER
MY MIND. I
LOADED TRAILERS
WITH HOMEBOY
CARLTON `ITCHY'
FITZGERALD WHO
RECITED NON
STOP TAPES
RHYMES FROM
GRAND WIZARD
THEODORE
AND
FANTASTIC 5
HE WOULD
NOT SHUT UP
AND HE
MADE THE
TIME MOVE!
THEY WERE
MAILBAGS OF AD
CIRCULARS

ITCHY WAS ALSO A
ROOSEVELT HIGH
BASKETBALL STAR SO W
GOT DIESEL LIFTIN
THEM BAGS

ITCHY LATER BECAME PARALYZED
WAIST DOWN FROM A CAR ACCIDENT IN
FLORIDA.. MOVED TO DALLAS HAD A CAR
DEALERSHIP GIG.. CAME TO EVERY PR SHOW

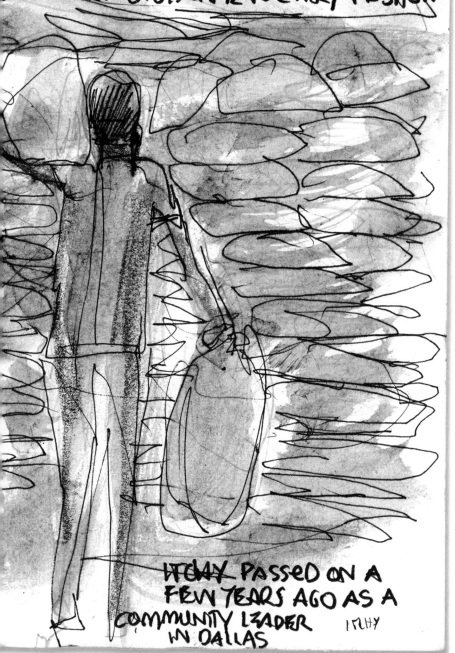

ITCHY PASSED ON A
FEW YEARS AGO AS A
COMMUNITY LEADER
IN DALLAS ITCHY

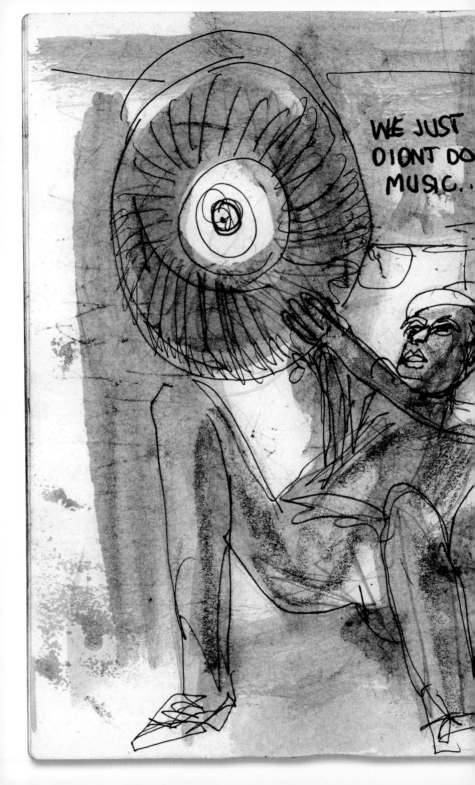

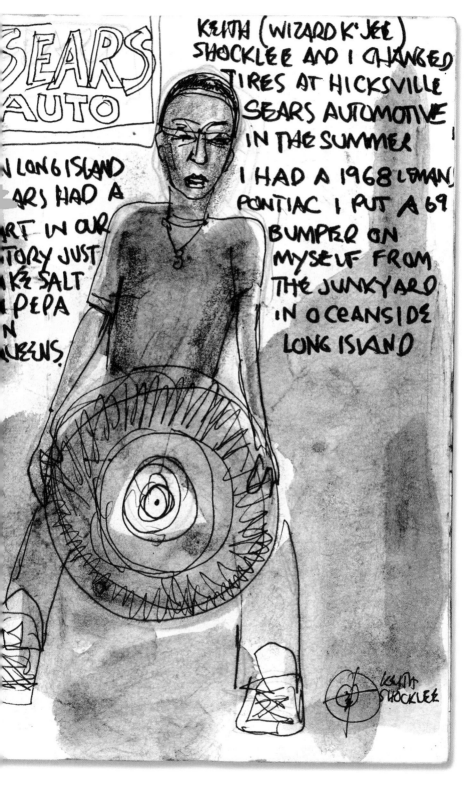

SEARS
AUTO

KEITH (WIZARD K· JEE)
SHOCKLEE AND I CHANGED
TIRES AT HICKSVILLE
SEARS AUTOMOTIVE
IN THE SUMMER

N LONG ISLAND
ARS HAD A
RT IN OUR
TORY JUST
KE SALT
PEPA
N
UEENS.

I HAD A 1968 LEMANS
PONTIAC I PUT A 69
BUMPER ON
MYSELF FROM
THE JUNKYARD
IN OCEANSIDE
LONG ISLAND

KEITH
SHOCKLEE

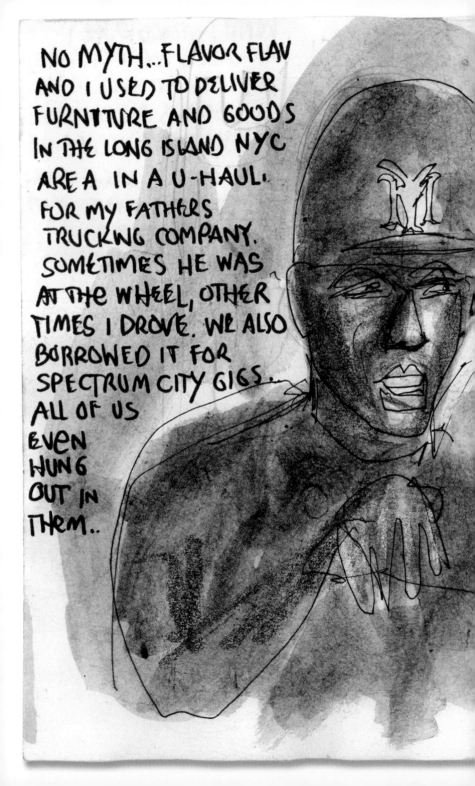

NO MYTH... FLAVOR FLAV
AND I USED TO DELIVER
FURNITURE AND GOODS
IN THE LONG ISLAND NYC
AREA IN A U-HAUL.
FOR MY FATHERS
TRUCKING COMPANY.
SOMETIMES HE WAS
AT THE WHEEL, OTHER
TIMES I DROVE. WE ALSO
BORROWED IT FOR
SPECTRUM CITY GIGS.
ALL OF US
EVEN
HUNG
OUT IN
THEM..

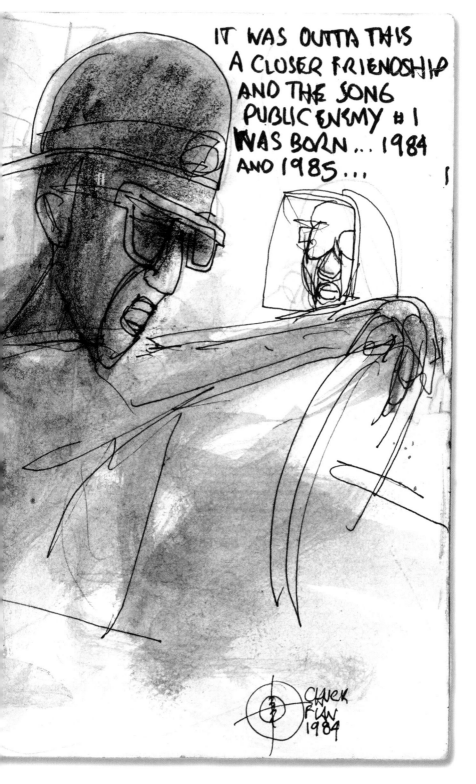

IT WAS OUTTA THIS
A CLOSER FRIENDSHIP
AND THE SONG
PUBLIC ENEMY # 1
WAS BORN ... 1984
AND 1985 ...

UPON COMPLETING THE DEBUT PUBLIC ENE
ALBUM.. WE HAD TO LEARN THE POLITICS (
RECORD COMPANY MAJORS. IT WAS SAI
LL COOL J' SOPHOMORE LP
TO RADIO WAS DELAYED
IN LIMBO... SORT OF...
THE CBS PRIORITY
ALBUM OF BRUCE
SPRINGSTEEN PUT
THE BEASTIE BOYS
LICENSED TO ILL
DEBUT FROM JUNE
TO OCTOBER.. SO OUR
PE DEBUT WAS PUSHED
INTO
1987!

SO MYSELF AND HANK SHOCKLEE
VISITED LL COOL J AT HIS GRANDPARENTS
HOME IN HOLLIS TO SEE IF WE COULD
ASSIST IN MARKETING AND PRODUCTION
WHICH WE EVENTUALLY DID. A TOTAL TEAM
EFFORT...

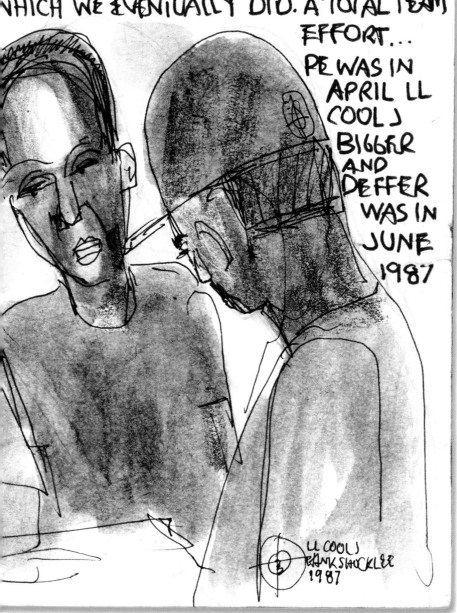

PE WAS IN
APRIL LL
COOL J
BIGGER
AND
DEFFER
WAS IN
JUNE
1987

LL COOL J
HANK SHOCKLEE
1987

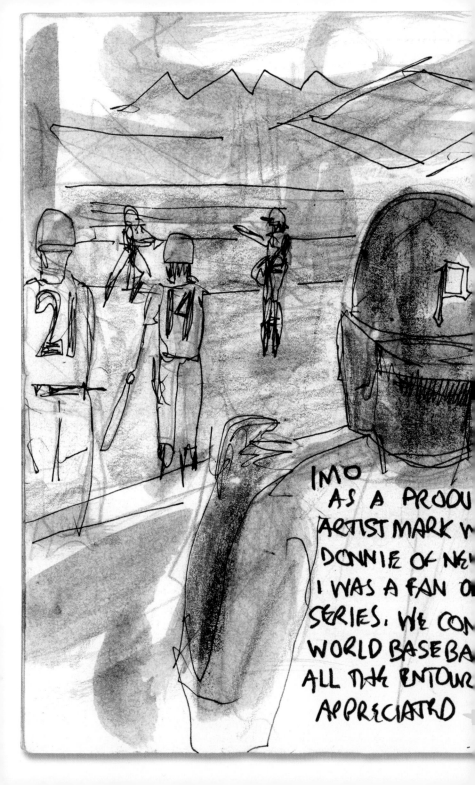

IMO
AS A PRODU
ARTIST MARK W
DONNIE OF NE
I WAS A FAN O
SERIES. WE CON
WORLD BASEBA
ALL THE ENTOUR
APPRECIATED

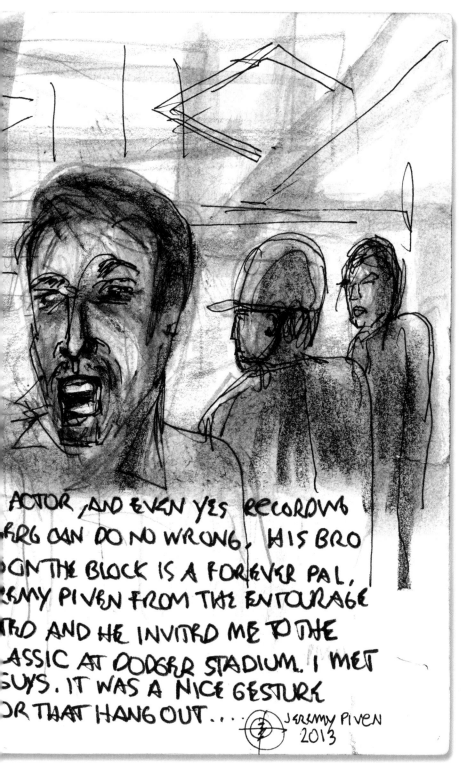

ACTOR, AND EVEN YES RECORDING
FRG CAN DO NO WRONG. HIS BRO
ON THE BLOCK IS A FOREVER PAL,
EMY PIVEN FROM THE ENTOURAGE
RD AND HE INVITED ME TO THE
ASSIC AT DODGER STADIUM. I MET
GUYS. IT WAS A NICE GESTURE
R THAT HANG OUT....

JEREMY PIVEN
2013

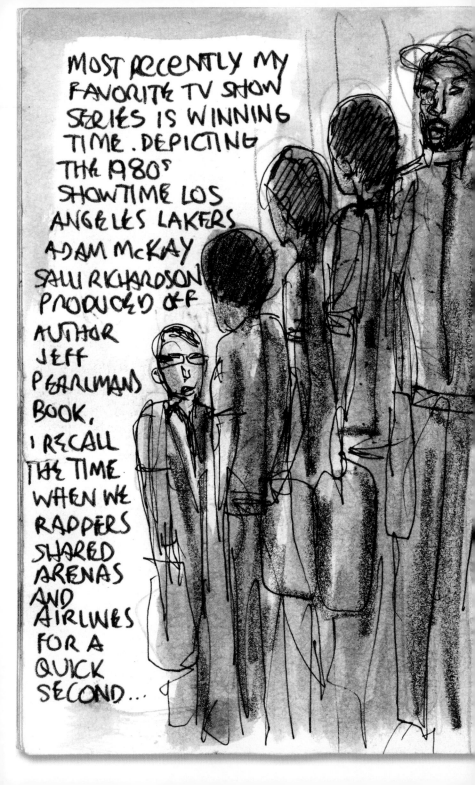

MOST RECENTLY MY
FAVORITE TV SHOW
SERIES IS WINNING
TIME. DEPICTING
THE 1980s
SHOWTIME LOS
ANGELES LAKERS
ADAM McKAY
SALLI RICHARDSON
PRODUCED OFF
AUTHOR
JEFF
PEARLMANS
BOOK.
I RECALL
THE TIME
WHEN WE
RAPPERS
SHARED
ARENAS
AND
AIRLINES
FOR A
QUICK
SECOND...

AT CLEVELANDS HOPKINS AIRPORT, WE
WAITED FOR A UNITED FLIGHT TO
CHICAGO AND BOOM THE WORLD
CHAMPION LOS ANGELES LAKERS
COME OFF THE PLANE. YES, THE
NBA FLEW COMMERCIAL IN 1987
EVEN THE CHAMPS. THE FIRST ONE OFF
THAT PLANE WAS
KAREEM ABDUL-
JABBAR..

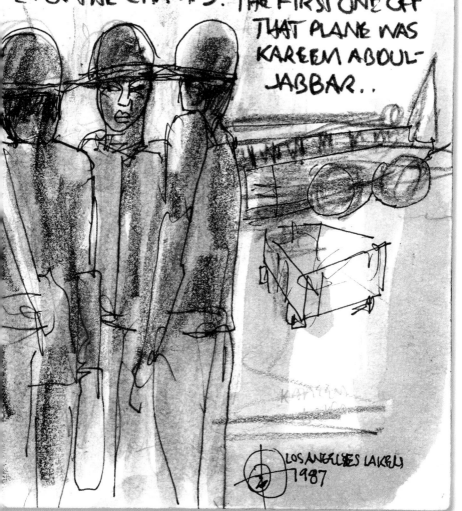

LOS ANGELES LAKERS
1987

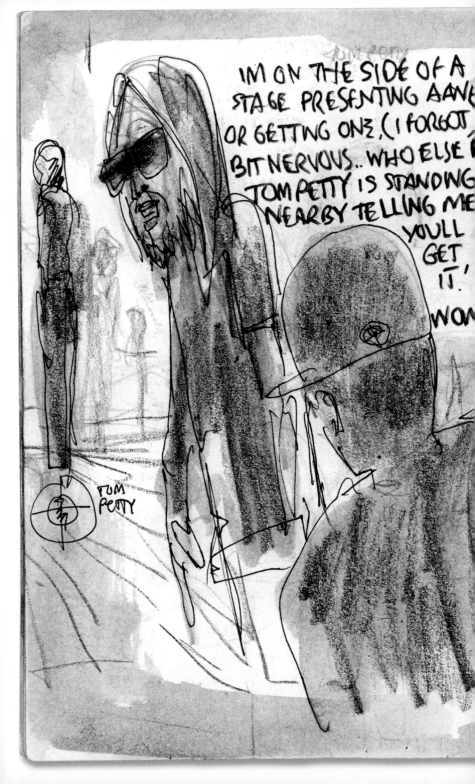

IM ON THE SIDE OF A
STAGE PRESENTING A AWE
OR GETTING ONE (I FORGOT
BIT NERVOUS.. WHO ELSE I
TOM PETTY IS STANDING
NEARBY TELLING ME
YOULL
GET
IT'
WON

TOM
PETTY

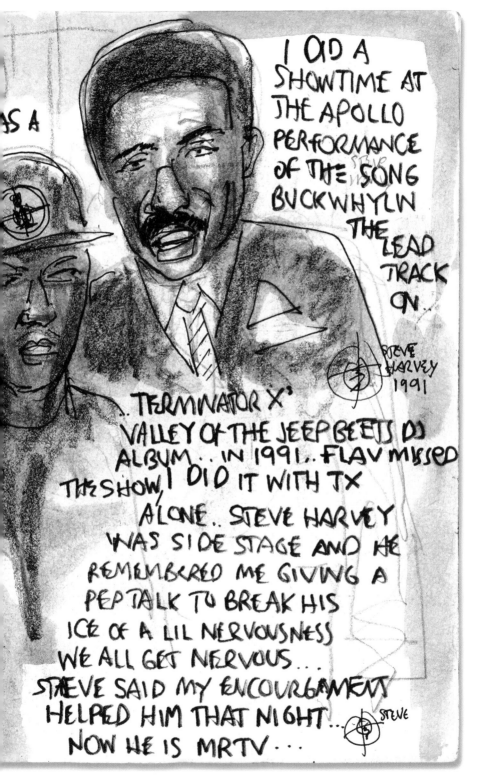

AS A

I DID A SHOWTIME AT THE APOLLO PERFORMANCE OF THE SONG BUCKWHYLN THE LEAD TRACK ON

STEVE HARVEY 1991

TERMINATOR X'
VALLEY OF THE JEEP BEETS DJ
ALBUM.. IN 1991.. FLAV MISSED
THE SHOW, I DID IT WITH TX
ALONE.. STEVE HARVEY
WAS SIDE STAGE AND HE
REMEMBERED ME GIVING A
PEP TALK TO BREAK HIS
ICE OF A LIL NERVOUSNESS
WE ALL GET NERVOUS...
STEVE SAID MY ENCOURGAMENT
HELPED HIM THAT NIGHT... STEVE
NOW HE IS MRTV...

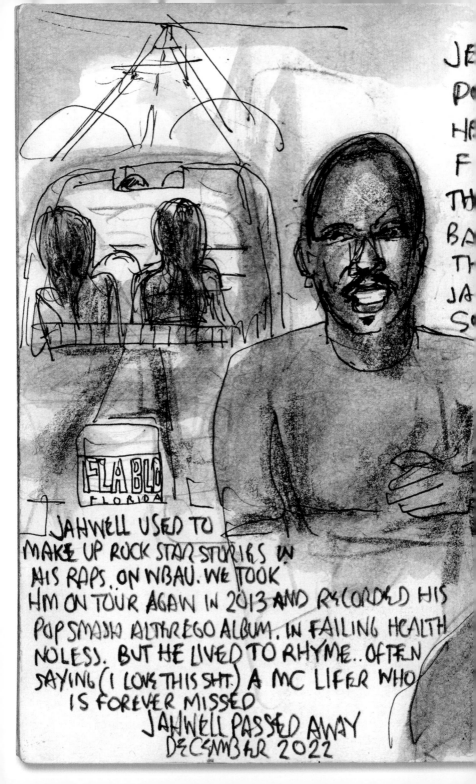

FLA BLO
FLORIDA

JAHWELL USED TO
MAKE UP ROCK STAR STORIES IN
HIS RAPS.. ON WBAU. WE TOOK
HIM ON TOUR AGAIN IN 2013 AND RECORDED HIS
POP SMASH ALTEREGO ALBUM.. IN FAILING HEALTH
NO LESS.. BUT HE LIVED TO RHYME.. OFTEN
SAYING (I LOVE THIS SHIT) A MC LIFER WHO
 IS FOREVER MISSED
 JAHWELL PASSED AWAY
 DECEMBER 2022

JE
PO
HE
F
TH
BA
TH
JA
SO

HEIGHT AKA ALMIGHTY JAHWELL AKA
NASH... WAS ONE OF MY FIRST RAP
GUYS FROM LONG ISLAND. FROM
ORT HE WAS ONE OF THE 3 MCS IN THE
N OF BAZERK NU SELF CONTROL AND THE
ERMERLY THE TOWNHOUSE 3. WHO WERE
2ST STARS ON OUR WBAU RADIO SHOWS.
WAS LATER A FIXTURE ON SOB AND
RECORDS AND LATER WE PUT THEM ON
TOUR AS OPENERS WITH LONS
WE PLAYED TAMPA AND THEY
DID A AMAZING SHOW. AFTERWARDS
I SAW JAH SITTING IN THE BACK
OF A CONVERTIBLE WITH 2 BLONDES
AT THE WHEEL, I LOOKED AT
HIS SMILING FACE AND TOLD HIM
BE SAFE! JAH GOT IN THE CAR
AND SAID 'JUST LIVIN THE
LIFE BABY' AND SAW THE
REAR LIGHTS DISAPPEAR
OVER THE BRIDGE...
A GREAT GUY..

JAHWELL
1991

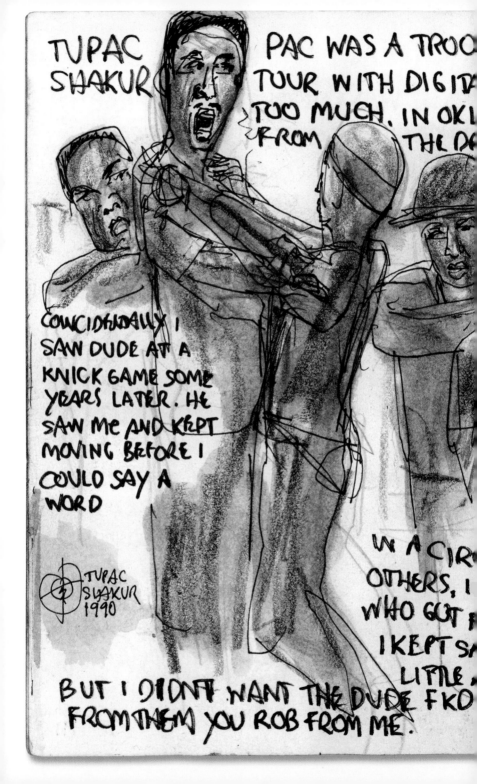

TUPAC
SHAKUR

PAC WAS A TROO
TOUR WITH DIGIT
TOO MUCH. IN OKL
FROM THE D

COINCIDENTALLY I
SAW DUDE AT A
KNICK GAME SOME
YEARS LATER. HE
SAW ME AND KEPT
MOVING BEFORE I
COULD SAY A
WORD

TUPAC
SHAKUR
1990

IN A CIR
OTHERS, I
WHO GOT
I KEPT SA
LITTLE

BUT I DIDN'T WANT THE DUDE FKO
FROM THEM YOU ROB FROM ME.

NO DOUBT IN HIS FIRST YEAR ON

DERGROUND MAYBE SOMETIMES A BIT

A CITY SOMEBODY STOLE MY JACKET

NG ROOM AMONGST OTHER THINGS..

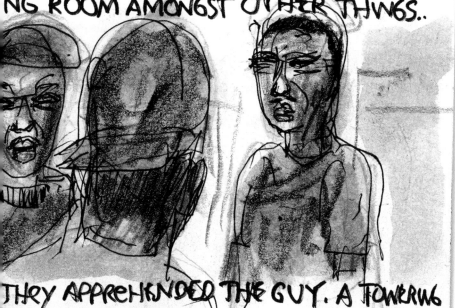

THEY APPREHENDED THE GUY. A TOWERING

OTHER. THE ITEMS WERE ESSENTIALLY

LVELESS BUT THE THOUGHT OF THEFT

AS BIG. I SAW HIM BEING INTERROGATED

OF QUESTIONS BY SECURITY AND SOME

E MIDDLE OF THE 'OTHERS' WAS PAC

P AND PUT BRO IN A SERIOUS YOKE.

S 'STOP, IT AINT THAT DEEP' BUT TO

. HE ADMITTED TO TAKING THE ITEMS

T PAC MADE A STATEMENT. YOU ROB

THE TIME WE DID SATURDAY NIGHT LIV
PLAYING A CONCERT AT U CONN EARLIER
NYC SNL, IT WAS FREEZING IN THE ST
BLACK NIGHT IT SEEMED. SPIKE LEE
CHRIS ROCK, REV JESSE JACKSON
HOSTED BY MICHAEL JORDAN
MILES DAVIS PASSED AWAY
THE CROWD WAS OLD
WHITE AND
STIFF TO RAP

FLAV
DOESNT
FOLLOW
SPORTS
SAYS
. . .

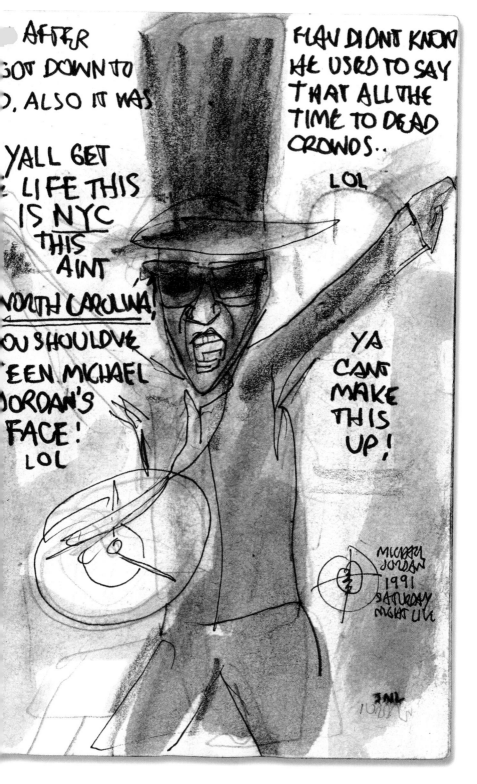

ANOTHER FUNNY MIKE TYSON STO[RY]
SPECIAL SHOW AT THOMAS AND M[...]
STAGE MIKE, OTHER CELEBRITIES [...]
JALIL FROM WHODINI, WHO IS [...]
 PRO[M...]

A DEF JAM TOUR PLAYED A ONE OFF
ARENA IN LAS VEGAS. ON THE SIDE
Y-E AND DR DRE ALONG WITH
PARTICULAR ABOUT HIS NAME BEING
RED CORRECTLY. HOWEVER FELLOW
BROOKLYNITE MIKE WAS CALLING
HIM OUT LOUD.. JAH-WHEEL

JAH-WHEEL!
JAH-WHEEL!
EVERYTIME MIKE CALLED
HIM OUT I SAW JALILS
FACE TIGHTEN UP... AS HE
OBLIGED MIGHTY MIKE.. BUT NO
WAS JALIL GONNA CORRECT
ON IT.. IT WAS HILARIOUS
TCH FROM THE SIDE

MIKE TYSON
JALIL HUTCHINS
WHODINI
1987

PLAYED MANY A CELEBRITY
PICK UP GAME BACK IN DA
DAY. THAT ONE TIME I
PLAYED AT DETROIT MERCY
AND NFL HOF BARRY
SANDERS WAS ON MY
 TEAM. HE'S 5-8.
 THE REFEREES WERE NBA
 PLAYERS CHRIS WEBBER
 AND JALEN ROSE...

HIS H
MY STAN
WH.

CELEBRITY

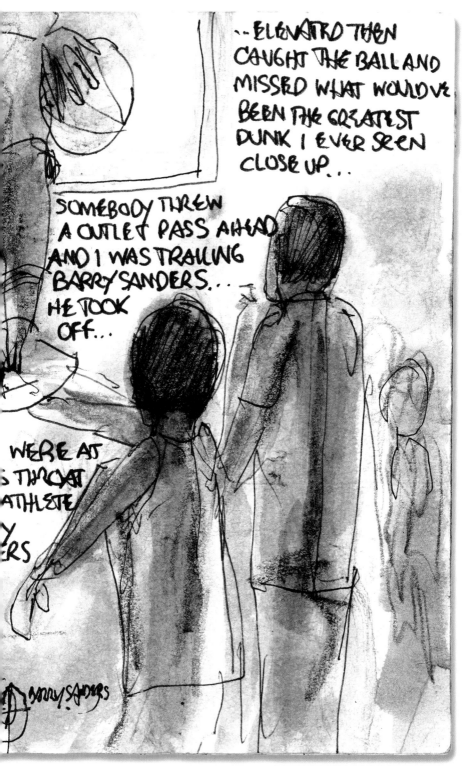

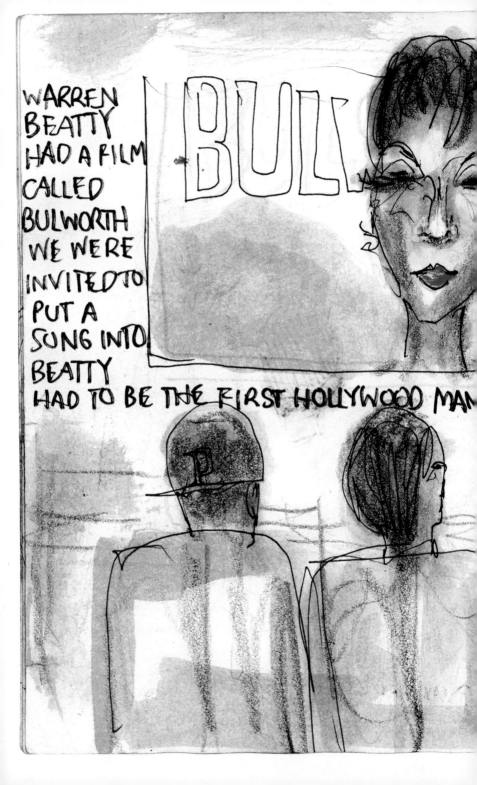

WARREN
BEATTY
HAD A FILM
CALLED
BULWORTH
WE WERE
INVITED TO
PUT A
SONG INTO

BEATTY
HAD TO BE THE FIRST HOLLYWOOD MAN

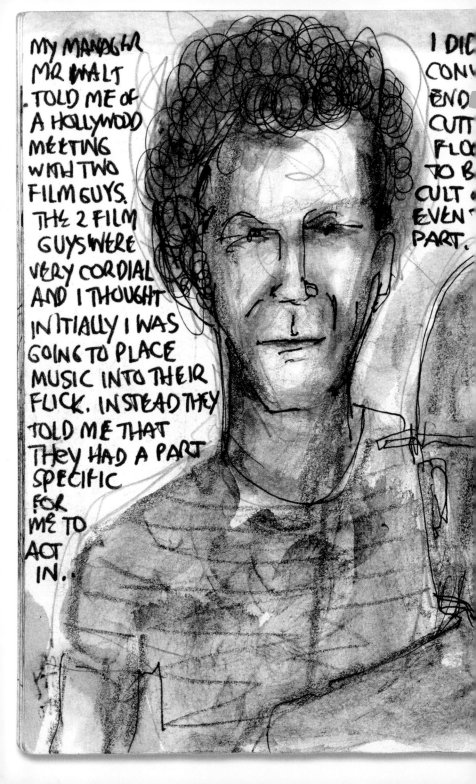

MY MANAGER
MR WALT
TOLD ME OF
A HOLLYWOOD
MEETING
WITH TWO
FILM GUYS.
THE 2 FILM
GUYS WERE
VERY CORDIAL
AND I THOUGHT
INITIALLY I WAS
GOING TO PLACE
MUSIC INTO THEIR
FLICK. INSTEAD THEY
TOLD ME THAT
THEY HAD A PART
SPECIFIC
FOR
ME TO
ACT
IN . .

I DID
CONV
END
CUTT
FLO
TO B
CULT
EVEN
PART.

AVE A DESIRE TO ACT BUT THEY WERE VERY
NG. SO I DID THE FLICK AND ALTHOUGH IT
ON THE
DUM
WENT ON
E A
IC..
UT

THE GUYS WERE
WILL FERRELL AND
ADAM McKAY..
THE MOVIE WAS
'ANCHORMAN'

WILL FERRELL
ADAM McKAY
2003

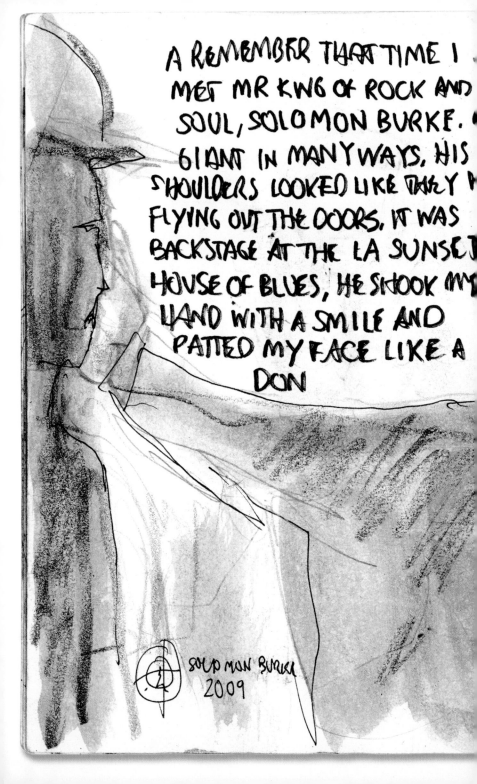

A REMEMBER THAT TIME I
MET MR KING OF ROCK AND
SOUL, SOLOMON BURKE.
GIANT IN MANY WAYS, HIS
SHOULDERS LOOKED LIKE THEY
FLYING OUT THE DOORS. IT WAS
BACKSTAGE AT THE LA SUNSET
HOUSE OF BLUES, HE SHOOK MY
HAND WITH A SMILE AND
PATTED MY FACE LIKE A
DON

SOLOMON BURKE
2009

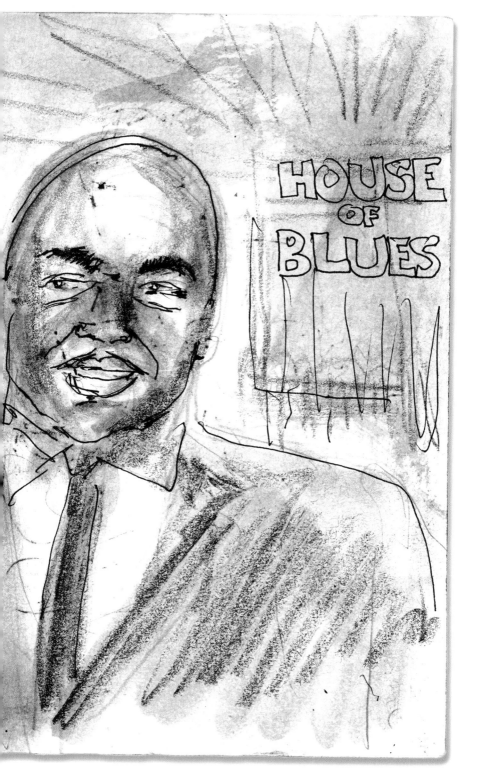

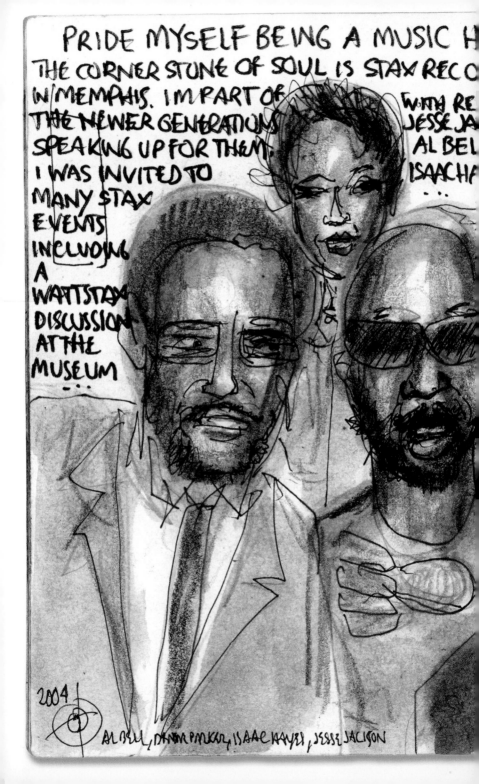

PRIDE MYSELF BEING A MUSIC H
THE CORNER STONE OF SOUL IS STAX REC O
IN MEMPHIS. I'M PART OF WITH RE
THE NEWER GENERATIONS JESSE JA
SPEAKING UP FOR THEM. AL BEL
I WAS INVITED TO ISAAC HA
MANY STAX ...
EVENTS
INCLUDING
A
WATTSTAX
DISCUSSION
AT THE
MUSEUM
...

2004

AL BELL, DEVON PARKER, ISAAC HAYES, JESSE JACKSON

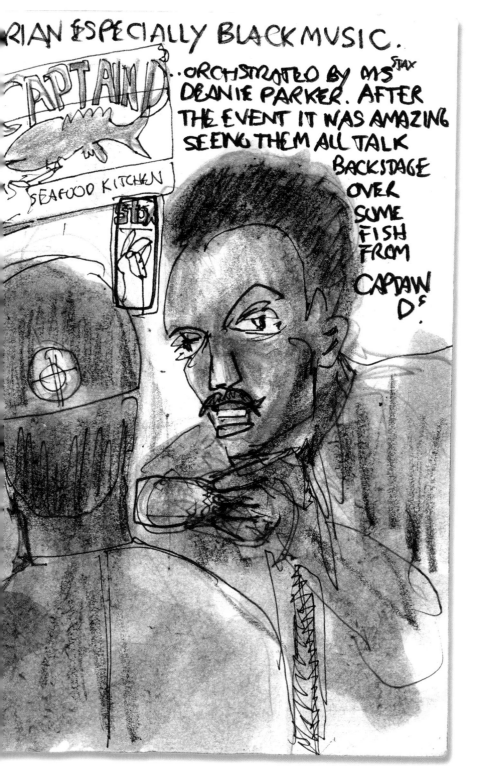

RIAN ESPECIALLY BLACK MUSIC.

..ORCHESTRATED BY MS STAX DEANIE PARKER. AFTER THE EVENT IT WAS AMAZING SEEING THEM ALL TALK BACKSTAGE OVER SOME FISH FROM CAPTAIN D'S.

CAPTAIN D'S
SEAFOOD KITCHEN

STAX

AT AIR AMERICA RADIO IN 2004 I EN___
MADDOW AND OTHER NOTABLE LIB___
OFFICE.. THE SHOW WAS CAL___
 UNFILTE___

UPTO UNTIL
NOVEMBER
2004 THE LIBS AND
WERE ALSO BABY STANDOO___
BOOMERS AND ON THE INT___
A CERTAIN SHOW WENT FU___
BRIAN WILSON WE WEN___
WAS A GUEST AND AND FO___
EVERYBODY AT MUS___
THE STATION HIS___
WAS NERVOUS
AS HELL
GIVEN HIS
REPUTATION
FOR
BEING
HARD

ED WITH LIZZ WINSTEAD AND RACHEL
TO GET THE SON OF A BUSH OUTTA

A

I
t.
w

CK
ABOUT
AND
STMAS
M

PIONEERING
MOMENT IN RADIO

WAS PROMOTING
PEOPLE AT THE
STATION WAS
LOOKING THROUGH
THE GLASS
AMAZED THAT
IT WENT SO
WELL...

BRIAN
WILSON
2004

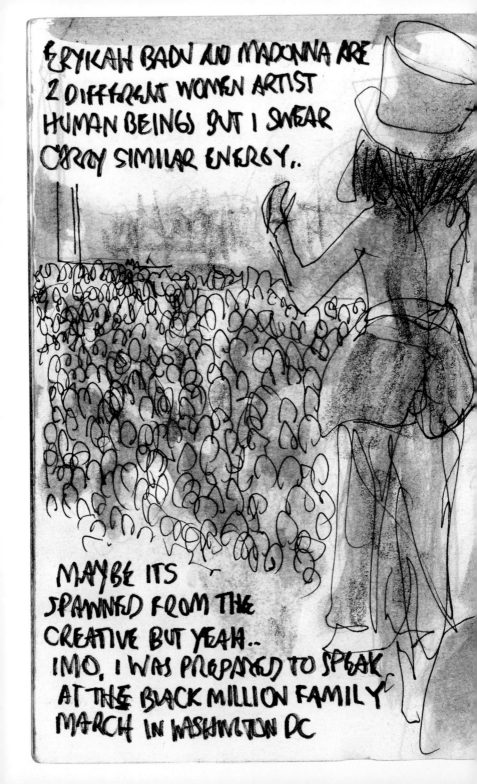

ERYKAH BADU AND MADONNA ARE
2 DIFFERENT WOMEN ARTIST
HUMAN BEINGS BUT I SWEAR
CARRY SIMILAR ENERGY..

MAYBE ITS
SPAWNED FROM THE
CREATIVE BUT YEAH..
IMO, I WAS PREPARED TO SPEAK
AT THE BLACK MILLION FAMILY
MARCH IN WASHINGTON DC

WAS GONNA SPEAK RIGHT BEHIND HER
T SHE GOT REALLY INTO HER FLOW IN
RONT OF THOSE HUNDREDS OF THOUSANDS

OF PEOPLE. IT WAS
SHOWTIME AND WHEN
SHE WAS DONE.. IT
WAS TIME FOR MINISTER
FARRAKHAN TO CLOSE OUT..

ERYKAH
BADU
2005

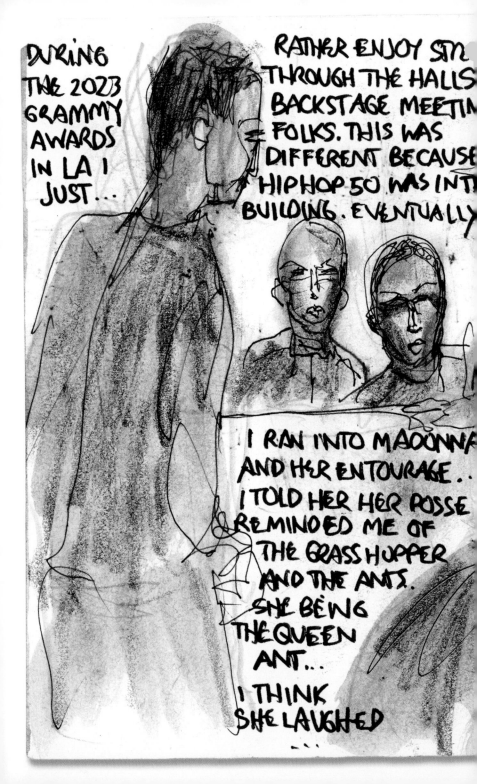

DURING THE 2023 GRAMMY AWARDS IN LA I JUST...

RATHER ENJOY STR[...] THROUGH THE HALLS[...] BACKSTAGE MEETIN[...] FOLKS. THIS WAS DIFFERENT BECAUSE[...] HIPHOP 50 WAS IN T[...] BUILDING. EVENTUALLY[...]

I RAN INTO MADONNA AND HER ENTOURAGE... I TOLD HER HER POSSE REMINDED ME OF THE GRASSHOPPER AND THE ANTS. SHE BEING THE QUEEN ANT...

I THINK SHE LAUGHED

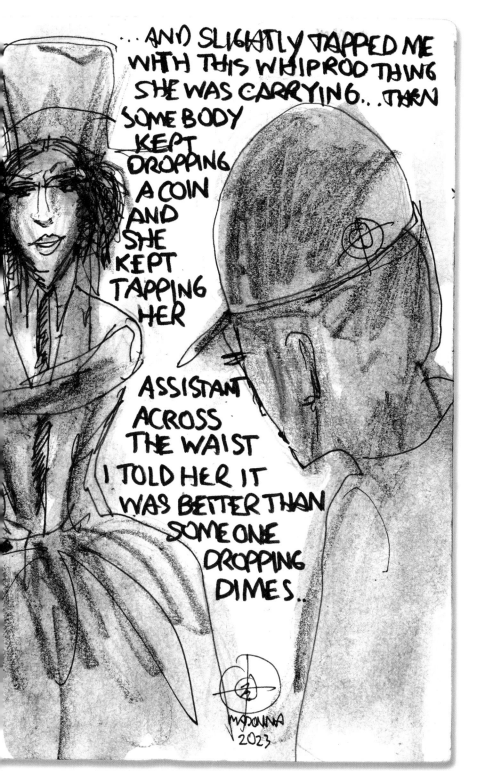

2023 THE 50TH YEAR OF HIP HOP I WAS
OF QUEEN LATIFAH ACROSS VARIOU
IT ALL STARTED OFF WITH FEBRUARY
WHERE LL COOL J AND QUESTLOVE A
DYNAMIC 12 MINUTE SET WITH OVER
DAMAGE, BACKSTAGE RUN, RAKIM
BUSTA RHYMES, LL AND I WERE
TALKING YELLING BETWEEN SETS
AND LO AND BEHOLD MS DANA
OWENS WAS ALL SOAKING IT IN
SITTING NEARBY. SAYING
THAT IT WAS SIMPLY
WONDERFUL TO LISTEN
IN AND BE PART OF A
GOLDEN MOMENT. WE
BOTH AGREED THIS
TOGETHERNESS WAS UNIQUE SPECIAL ON
GREAT NOTE AS OPPOSED TO THE ALTERN
COINCIDENTALLY THAT ALTERNATIVE HAP
ONLY WEEKS LATER WHEN DAVE FROM
TRAGICALLY PASSED AWAY. WE SAW EA
NODDING THE FACT OF WHAT WE SAI

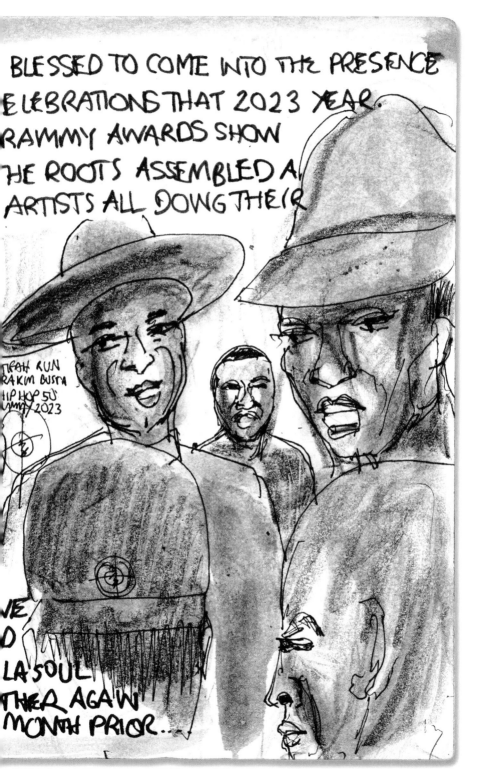

BLESSED TO COME INTO THE PRESENCE
ELEBRATIONS THAT 2023 YEAR.
RAMMY AWARDS SHOW
HE ROOTS ASSEMBLED A
ARTISTS ALL DOWG THEIR

TIFAH RUN
RAKIM BUSTA
HIP HOP 50
MMY 2023

NE
D
LA SOUL
THER AGAW
MONTH PRIOR...

IVE SAID THIS BEFORE IF I COULD
START A RAP CAREER ALL OVER AG
I WOULD BE METHOD MAN AS A MC..C
MEMBER OF THE GREATEST GROUP OF M
VOICE ENERGY WIT AND A NAME O
THE SUPERHERO BOOKS..

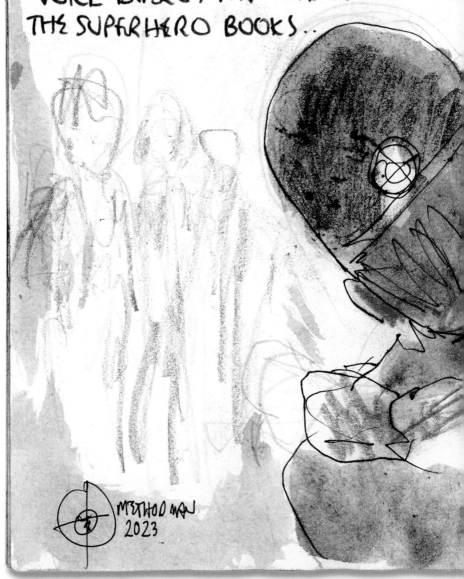

METHOD MAN
2023

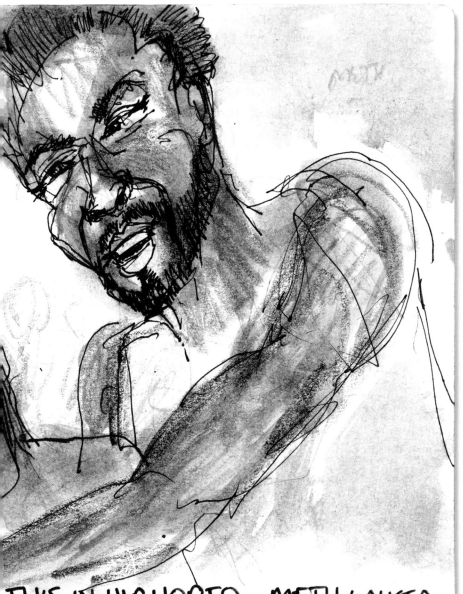

THIS IN HIP HOP 50... METH WALKED
OFF STAGE SPITTING THE WHOLE
BRING THE NOISE IN MY EAR AFTER
THE FINALE...

DE LA SOUL IT SEEMS I'VE KNOWN
I MET THEM. PRINCE PAUL PLA[Y]
THE PUBLIC ENEMY·STETSASONIC
SUMMER 1987. A SUMMER BUS E[...]
ALBUMS TO FORWARD HIP HOP. N[...]
IN FULL GEAR AND
3 FEET HIGH AND
RISING WHICH
PRINCE PAUL·
WAS CO PRODUCING
WELL THESE
AMITYVILLE
STRONG ISLANDERS
WERE THE
NEXT
FUTURE...
THEY
WERE
CORDIAL
BUT...

DAVE
TRUGOY
2019

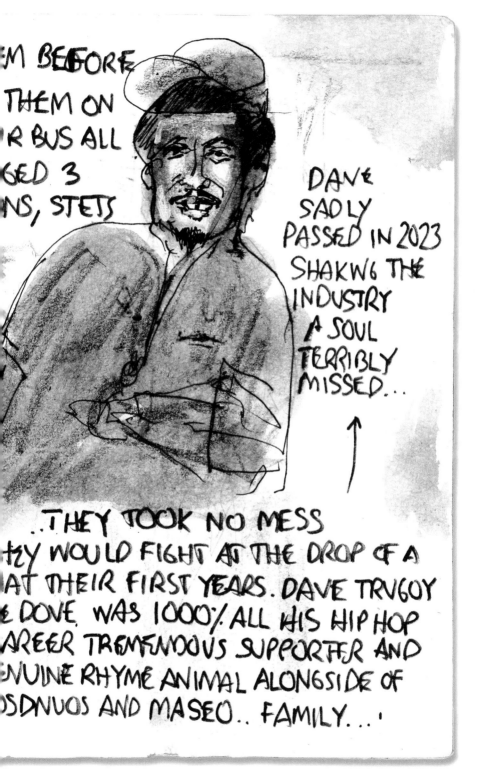

M BEFORE
THEM ON
R BUS ALL
GED 3
NS, STETS

DAVE
SADLY
PASSED IN 2023
SHAKING THE
INDUSTRY
A SOUL
TERRIBLY
MISSED...

↑

..THEY TOOK NO MESS
tzy WOULD FIGHT AT THE DROP OF A
AT THEIR FIRST YEARS. DAVE TRUGOY
e DOVE WAS 1000% ALL HIS HIP HOP
AREER TREMENDOUS SUPPORTER AND
ENUINE RHYME ANIMAL ALONGSIDE OF
OSDNUOS AND MASEO.. FAMILY...

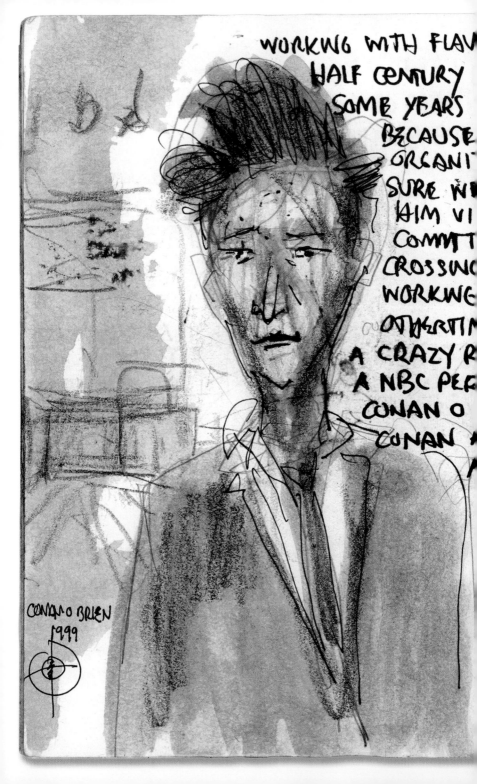

AV HAS BEEN NEARLY A
OP ROLLER COASTER RIDE
DIFFERENT THAN OTHERS
ENTIRE
N MADE
PED

NOT
OUR
HS.
IT WAS
.. AFTER
IANCE ON
N JUST
I SAT
RWARDS.

IN SILENCE
WHEN IT WAS
ALL OVER...
HALF LAUGHING
SHAKING OUR
HEADS..

CONAN WAS
LIKE SO HES
REALLY LIKE
A TORNADO
EH?

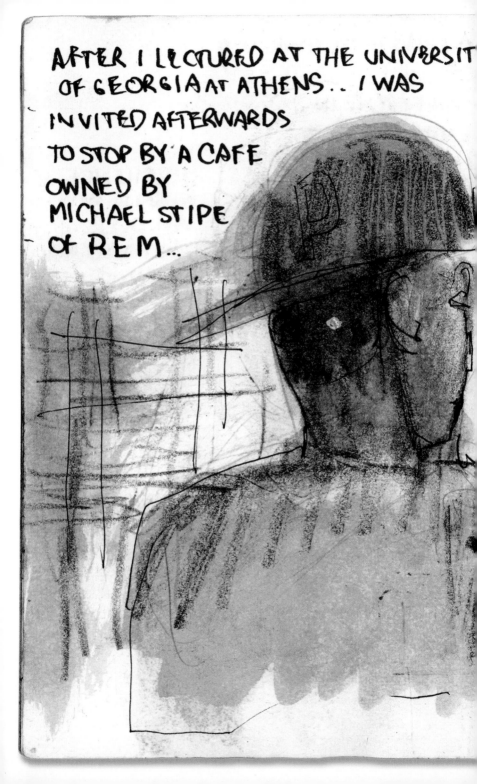

AFTER I LECTURED AT THE UNIVERSIT
OF GEORGIA AT ATHENS.. I WAS
INVITED AFTERWARDS
TO STOP BY A CAFE
OWNED BY
MICHAEL STIPE
OF R E M ...

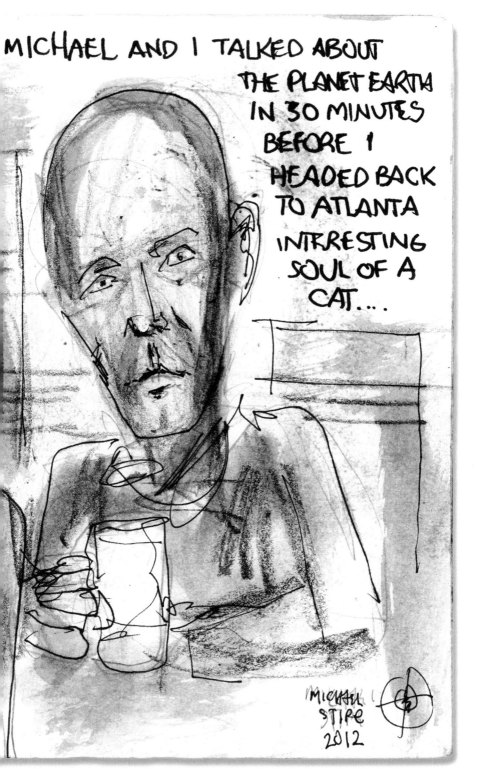

MICHAEL AND I TALKED ABOUT THE PLANET EARTH IN 30 MINUTES BEFORE I HEADED BACK TO ATLANTA INTRRESTING SOUL OF A CAT....

MICHAEL STIPE 2012

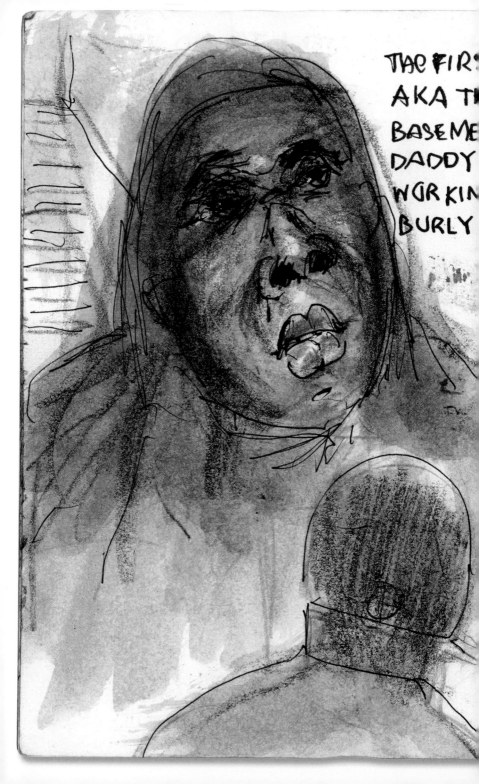

THE FIRS
AKA T
BASEME
DADDY
WORKIN
BURLY

ME & MET BIGGIE SMALLS
.TORIOUS BIG WAS IN THE
.TUDIO OF MY GOOD PAL
F STETSASONIC. ODAD WAS
N A BUNCH OF ACTS AND THIS
E CAME IN PEERING UNDER
 HIS HOODIE...
 ODAD SAID 'CHUCK
 THIS IS BIGGIE SMALLS'
 I SAID HMM DOPE, A
 NAME FROM LETS DO IT
 AGAIN .. WITH POITIER AND
 COSBY, WE SHOOK HANDS
 NICE GESTURES AS I
 SEEMINGLY WAS
 LOOKING STRAIGHT
 UNDER HIS NOSTRILS

NOTORIOUS BIG
DADDY O
1993

BIG ODAD

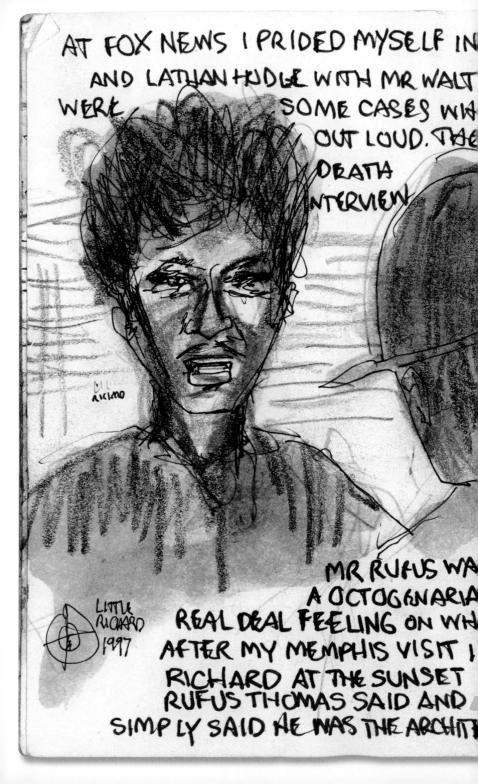

AT FOX NEWS I PRIDED MYSELF IN
AND LATJAN HODGE WITH MR WALT
WERE SOME CASES WIT
 OUT LOUD. THE
 DEATH
 INTERVIEW

LITTLE
RICHARD
1997

MR RUFUS WA
A OCTOGENARIA
REAL DEAL FEELING ON WH
AFTER MY MEMPHIS VISIT I
RICHARD AT THE SUNSET
RUFUS THOMAS SAID AND
SIMPLY SAID HE WAS THE ARCHIT

COVERAGE OF THE UNDERVOICED...ERIC
E VERY HELPFUL IN THE WORK. THERE
THE CULTURAL CROSS SECTIONS SCREAMED
TH ANNIVERSARY OF ELVIS PRESLEYS
IN 1997 CALLED ME TO MEMPHIS TO
RUFUS THOMAS INSIDE
SUN
STUDIOS

MR RUFUS

ULY W HIS WORDS
EENAGER AS HE GAVE ME THE
R MR E WAS REALLY THE 'KING'.
W TO INTERVIEW THE GREAT LITTLE
TT. HE SAID SIMILAR TO WHAT
ED 'KING OF WHAT' HIS EXPLANATION
NO ELVIS HAD TO SHARE THE THRONE

1997
RUFUS
THOMAS

WE WERE INVITED BY THE NATION O[...]
A NEW YORK CITY UNITED NATIONS GAT[...]
REPRESENT OUR
DEMOGRAPHIC. THERE
WERE GIGANTIC SCREENS
ON THE 42ND STREET EAST
END. THERE WAS A
GIGANTIC SCREEN
SHOWING 3 LEADERS
GIVING SPEECHES
CAESAR CHAVEZ FROM
VENEZUELA, MAHMOUD
AHMADINEJAD FROM
IRAN AND
MUAMMAR
GADDAFI
FROM LIBYA
THEY WERE
TALKING FOR
HOURS IT
SEEMED...
IT WAS
INTERRUPTED
BY PRESIDENT OBAMA
LANDING AT THE UN IN A HELICOPTER

AM TO

NG TO

IT WAS A HINT IN THE BACK OF OUR MINDS THAT WITH ALL THIS PRESENTATION IN THE USA THAT THINGS WERE NOT GOING TO END WELL FOR THE 3 OF THEM. 2 OF THEM WERE TO BE NO LONGER IN OT LONG AFTERWARDS

GADDAFI
AHMADINEJAD
CHAVEZ

2009

JN

I WAS DOING A CONFERENCE CON
GARY LOUIS CHARLES AND HIS SPC
PARTICIPATED IN SPEAKING AND GET
MY OLYMPIAN BOYHOOD HEROES SP
MOSES. I HAD DONE BASKETBALL DOC

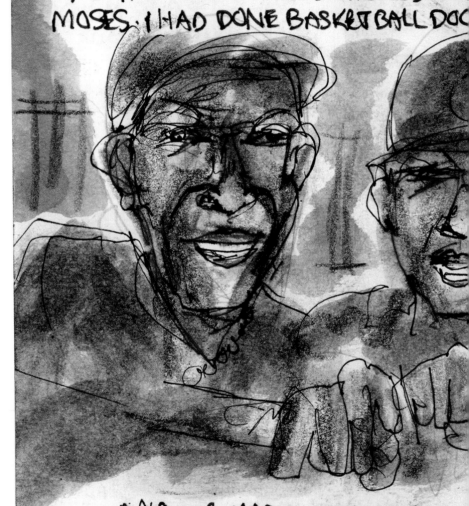

AND WE HAD A GREAT FAN-
TIME MEETING EDWIN WHO I WAS FAN OF
ENLIGHTENING AS I TOLD HIM HE WAS TH
THAT HAD A HIGHWAY NAMED AFTER

ON WITH MY ROOSEVELT HOMEBOY
MANAGEMENT EXTRAVAGANZA. I
A AWARD. OTHER AWARDEES WERE
R HAYWOOD AND TRACK GOD EDWW
R SPENCER A FEW YEARS BACK

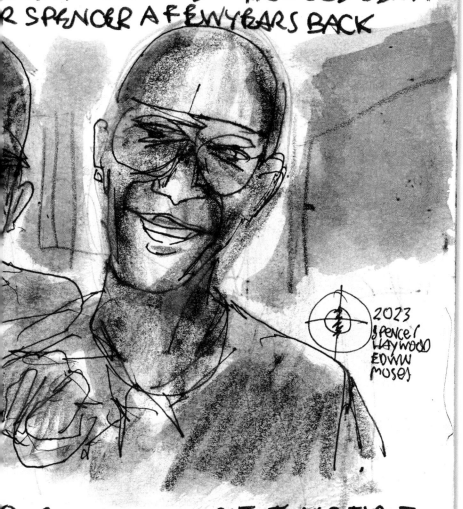

2023
Spencer
Haywood
EDWW
Moses

RELATIONSHIP, BUT IT WAS FIRST
INTELLECT AS WELL AS HIS ATHLETIC FEATS,
ST BROTHER I KNEW AROUND MY AGE
IN DAYTON HIS HOME

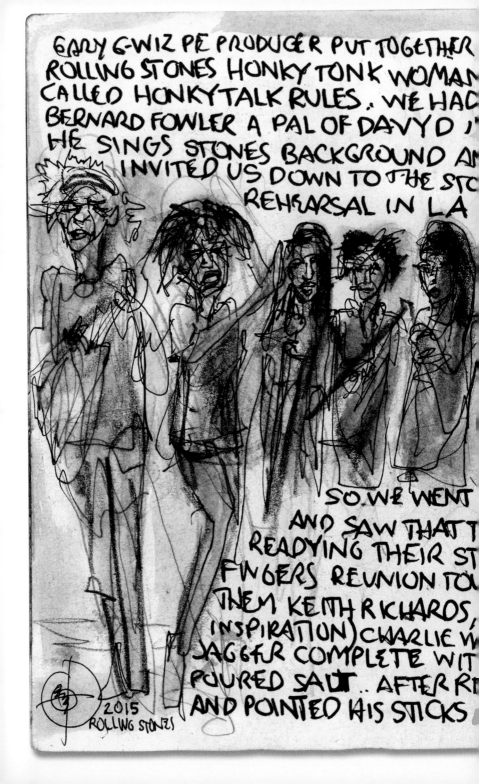

GARY G-WIZ PE PRODUCER PUT TOGETHER
ROLLING STONES HONKY TONK WOMAN
CALLED HONKYTALK RULES. WE HAD
BERNARD FOWLER A PAL OF DAVY D,
HE SINGS STONES BACKGROUND AN
INVITED US DOWN TO THE STO
REHEARSAL IN LA

SO. WE WENT
AND SAW THAT T
READYING THEIR ST
FINGERS REUNION TO
THEM KEITH RICHARDS,
INSPIRATION) CHARLIE W
JAGGER COMPLETE WIT
POURED SALT .. AFTER R
AND POINTED HIS STICKS

2015
ROLLING STONES

SMOKNG $VERSION RE MAKE OF THE
R A PUBLIC ENEMY INTERPOLATION
GET PERMISSION
EGEND

AFTERWARDS
WE TOOK PICS
AND TOLD US
THEY DIDNT
CONTROL THE
SONG AND WISHED
US LUCK WITH
ABKCO WHICH
WE DID
FROM A
COOL
LADY
THERE

N WERE
Y
LL OF
WOOD (MY ART/
AND MICK
NCING ON
2SAL CHARLIE WATTS PLAYED A BEAT
E !? MIND BLOWING !.

THAT TIME I SAT BETWEEN JAM
A PANEL ON RACE AND CULTUR
IN NASHVILLE. I WAS PRETTY AM
TOP BUT THE CALM WISDOM STY
OF THESE TWO OGs SHOWED ME
YOU DIDN'T HAVE TO BE LOUD

PANEL.

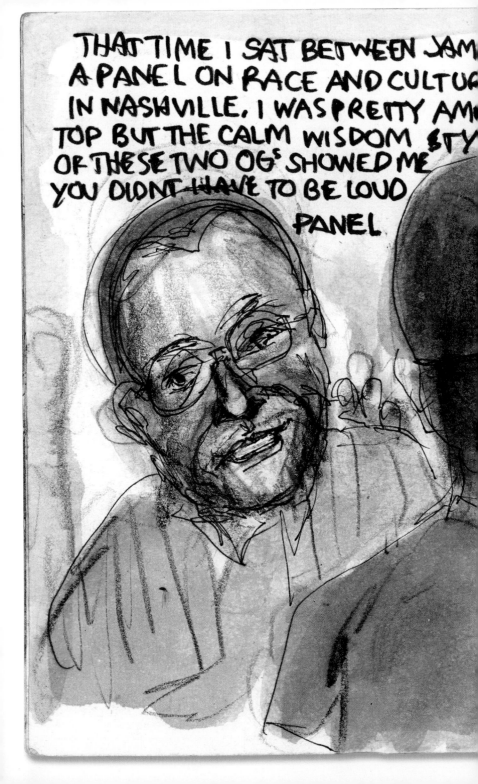

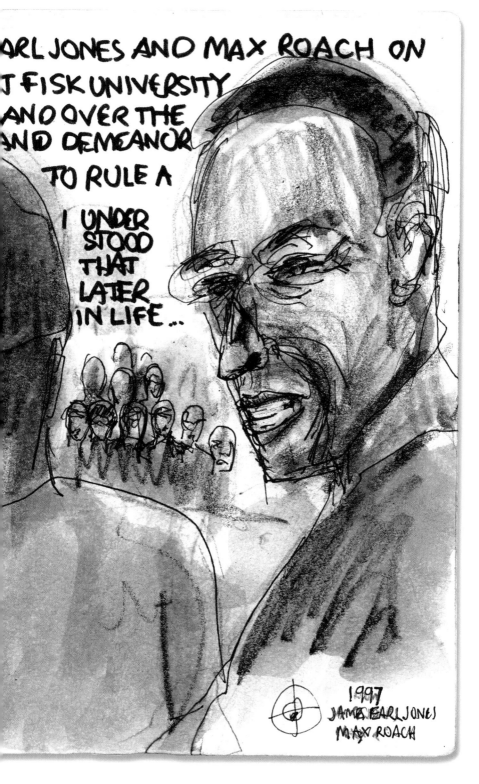

1990 PUBLIC ENEMY HAD A LOTTA C(

AND CONFUSION
ABOUT US IN
THE USA
MEDIA, YET
WE WERE
INVITED TO
PLAY ON
THE JOAN
RIVERS
TV SHOW.
SHE ASKED
THE DIFFICULT
...

QUESTIONS AN
ANSWERED TH
THIS TIME WE
OUR DEFENSIV

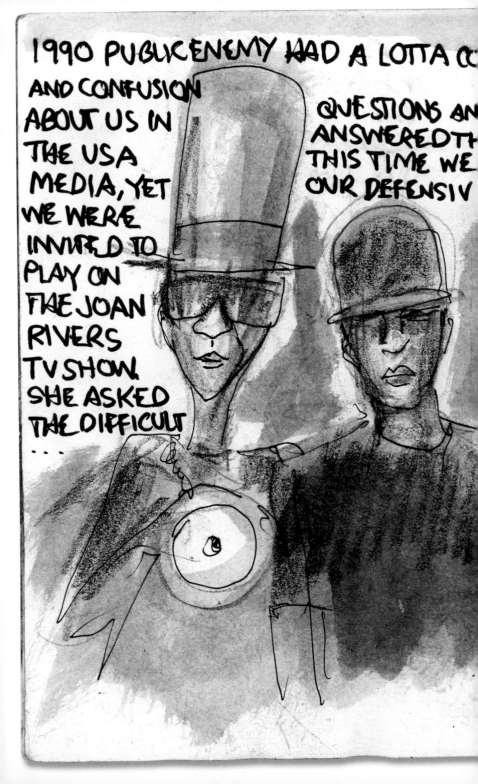

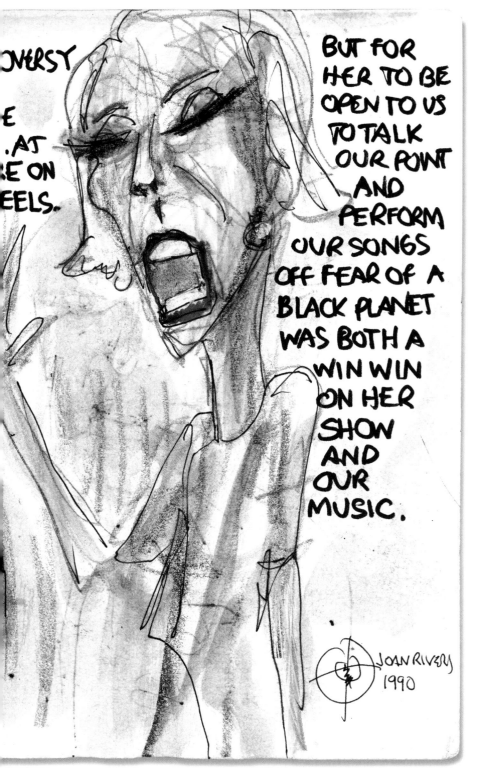

OVERSY

E

. AT

E ON

EELS.

BUT FOR HER TO BE OPEN TO US TO TALK OUR POINT AND PERFORM OUR SONGS OFF FEAR OF A BLACK PLANET WAS BOTH A WIN WIN ON HER SHOW AND OUR MUSIC.

JOAN RIVERS
1990

QNITE A FEW FOLKS IN THE USA R
THAT I HELPED USHER IN THE INFA
FROM A MORNING BATTLE INTERVIEW
I SMASHED HIM WHILE TIRED IN CHIC
FOX NEWS CZAR WHO REMINDED M
ROGER AILES WHO
ASKED FOR A NY
MEETING. I IMPRESSED
HIM ENOUGH TO
GIVE ME MY OWN
SLOT IN THEIR
PROGRAMMING. I
HAD FULL AUTONOMY
I DID A VOICE FOR
THE VOICELESS
WHENEVER I
WANTED
CALLED
'ON THE
REAL'
NAMES
LUKE
O REILLY
COMBS
HANNITY..

ROGER
AILES
1997

A EYEBROW WHEN I TELL THEM
S FOX NEWS ON CABLE TV. IT CAME
RACE WITH JUDGE ROBERT BORK.
. IT CAUGHT THE ATTENTION OF
THE GUY IN THE MOVIE 'PORKY'S...

FOX
NEWS

IN 1999 I
WENT BACK
TO FULL
TOURING
I LEFT
AND THEY
WENT FAR
RIGHT...

ERED THE
NETWORK TO
THE MODERATE
AND RIGHT...
I WAS MAD
LEFT..

AT THE CENTURY TURN I GOT HEAV
WAS THE WAY OUT FROM THE COR
EMERGED AND I WAS GOING
TO FIGHT FOR THEIR
SURVIVAL BY ANY ART
MEANS
...

RAPSTATION

TO THE WWW. FILE SHARING
TE DOMINANCE OF THE 1990? NAPSTER
ALSO I CAMPAINED FOR DIAMOND RIO
AND KAZAA AND OTHERS BECAUSE IT
WAS A WAY OF ART SURVIVAL...
LEADING TO
A PBS
SUMMITT

WITH
LARS
ULRICH
FROM
METALLICA
ON THE

CHARLIE ROSE
SHOW

LARS HELD HIS
OWN AS DID I
AND WE SEE THE
WORLD WE ARE
WITHIN

CHARLIE
ROSE
LARS
ULRICH
2000

SUMMER OF HAMN
HOLLOWPOINTLESSNESS AIDING MASS NIHILISM

Hardcover, 240 pages, $34.95, 978-1-63614-152-7

"Public Enemy front man Chuck D follows up *STEWdio* with a striking graphic narrative archive of gun violence and collective misery during the summer of 2022 . . . It's a bristling and necessary catalogue of collective anguish."
—*Publishers Weekly*, starred review

"In *Summer of Hamn*, hip-hop icon Chuck D describes the tragedy of gun violence through a compilation of original illustrations and verse. The raw emotion comes through in every page, as the legendary storyteller describes the devastating impact gun violence has had on our community."
—*Root*

"With his latest work of graphic nonfiction, Chuck D uses his art and hip-hop rhymes to show how the US has been held hostage by gun violence and a growing sense of hopelessness . . . A focused, fresh, urgent text filled with pictures worth 1,000 words and rhymes worth thousands more."
—*Kirkus Reviews*, starred review

RAPILATES

BODY AND MIND CONDITIONING IN THE DIGITAL AGE

by Chuck D and Kathy Lopez

Hardcover, 92 pages, $34.95, 978-1-63614-152-7

"Chuck D, the leader/cofounder of the hip-hop group Public Enemy, and Lopez, his Pilates instructor, show how people of all ages can benefit from the practice of this body-conditioning regime ... A solid and fun introduction to Pilates for both beginners and readers with some knowledge of Pilates. Fans of hip-hop will appreciate this book too."
—*Library Journal*

Enemy Books is an imprint of Akashic Books. Our books are available from the Akashic Books website, www.akashicbooks.com, and wherever books are sold.